IMAGES
of Aviation

KANSAS CITY
B-25 FACTORY

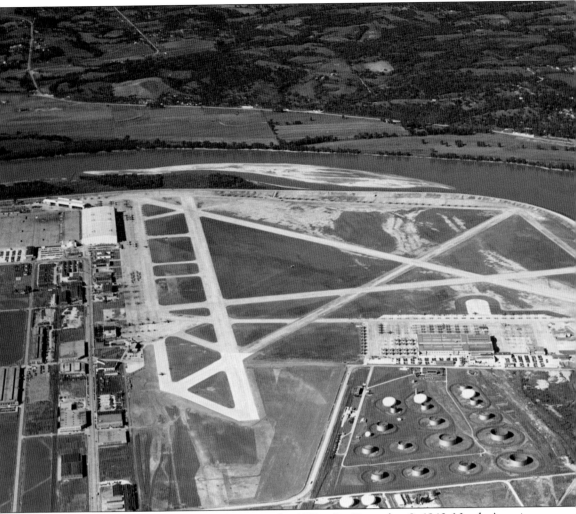

There had been an airport at Fairfax since the 1920s. On December 2, 1940, North American Aviation, Inc., president Dutch Kindelberger visited it and the future plant site, a 75-acre alfalfa field, before he telegraphed the following: "Have inspected Fairfax site and it is okay. Airport small but suitable for immediate needs with improvements." In a short 13 months, a factory was erected, employees were hired and trained, equipment was installed, and the first B-25 was completed. The main factory is on the left, while the Modification Center is visible on the right.

ON THE COVER: The crowning achievement in the brief, but fascinating, history of the Kansas City B-25 factory was a ceremony to bestow the Army-Navy "E" (for excellence) Award. The outdoor event was held under dusky autumn skies at 5:30 p.m. on October 6, 1944. Thousands of people were in attendance. At the event, dignitaries made short speeches, a special banner was hoisted up a flagpole, and an Army band played patriotic tunes as military members saluted. The North American Aviation, Inc., of Kansas plant had been hastily established at the Fairfax Airport three years earlier. A mere 12 months later, after a total of 6,608 medium bombers were constructed, the entire facility was shut down, vacated, and abandoned even more quickly.

IMAGES
of Aviation

KANSAS CITY
B-25 FACTORY

John Fredrickson and John Roper

ARCADIA
PUBLISHING

Published by Arcadia Publishing
Charleston, South Carolina

Printed in the United States of America

Library of Congress Control Number: 2013955169

For all general information, please contact Arcadia Publishing:
Telephone 843-853-2070
Fax 843-853-0044
E-mail sales@arcadiapublishing.com
For customer service and orders:
Toll-Free 1-888-313-2665

Visit us on the Internet at www.arcadiapublishing.com

John Fredrickson wishes to dedicate this book to his four uncles who served in war. Erling Fredrickson went to war in Korea; Henry Fredrickson served with Army Air Forces in Alaska; Robert A. Johnson arrived in Europe too late to see action but remained there with occupation forces until 1946; Wayne Schellenger fought on the ground in the South Pacific. All were from Rhinelander, Wisconsin, and survived their military service.

John Roper would like to dedicate this book to his grandmother Mary Ann Lacy, who, while her husband was deployed in the South Pacific serving in the Navy, worked at the factory along with her sisters Rose and Barbara. Mary lived at Thirty-eighth Street and Parallel Parkway in a small two-room house with no plumbing. While her husband was away, she would leave her two children with her mother-in-law up the street in order to go to work every day. Mary never drove, but she always found a way to get to work. Her sisters lived in the West Bottoms. It was dedicated people like these ladies who helped make America the strongest nation in the world.

CONTENTS

Acknowledgments 6

Introduction 7

1. North American Aviation, Inc. 9

2. Evolution of the B-25 13

3. History of Fairfax Airport and Plant Construction 25

4. Getting Production Started 33

5. Visitors and Important Events 61

6. Accidents and Incidents 87

7. US Army Air Corps Ferry Command 93

8. Production Hits Stride 105

9. Shutdown and Clearing the Factory 123

ACKNOWLEDGMENTS

The generous assistance and cooperation of Michael Lombardi and Thomas Lubbesmeyer of the Boeing Historical Archives in Bellevue, Washington, were invaluable to the creation of this book.

The Truman Museum and Library of Independence, Missouri, provided details regarding the presidential arrival at Fairfax Airport on June 26, 1945. The General Motors Heritage Center was the source for the final two photographs, which depict a Kansas City–area automobile factory of the late 1940s. The Eisenhower Presidential Library of Abilene, Kansas, pointed the way to the wartime history of General Eisenhower's Fairfax-built B-25J transport that was assigned for his exclusive use from May 1944 to May 1945.

Appreciation also extends to the authors of three previous works, which document North American Aviation, Inc., of Kansas and/or the B-25. Norm Avery was hired by North American in 1940 and started his career as a draftsman on the B-25 project at Inglewood. He devoted his life to documenting the history of North American aircraft. His 1994 book, *B-25 Mitchell: The Magnificent Medium,* is considered by many historians to be the primary authority on that model. George R. Bauer lived in the Kansas City area and interviewed numerous alumni of the Fairfax plant. His 1995 book is called *Fairfax Ghosts,* and Norm Avery assisted Bauer in researching it. The third source is an article titled "'We All Had a Cause': Kansas City's Bomber Plant, 1940–1945," in *Kansas History: A Journal of the Central Plains,* Winter 2005/2006 issue. It was written by Richard Macias.

Unless otherwise indicated, all images are official North American Aviation, Inc., photographs and graphics. Copyright resides with the Boeing Company. They are used with permission.

INTRODUCTION

The span of the 1920s and 1930s was the "period between the wars"—an era of rapid innovation within the still adolescent business of aviation. Improved technology made its way back and forth between civil and military designs. Airframe materials shifted from wood and cloth to metal, cantilevered wings were introduced, engines became more powerful as reliability improved, communication by radio was refined, airborne navigation was evolving, and civil air transportation had grown beyond mail and into passengers. The Douglas DC-3 helped bring the airline business to maturity. It was one of the first designs that was not obsolete within a very few years.

The late 1930s found American war production ramping up well before the Pearl Harbor attack because of exports to war-torn Europe. Historians have long agreed that the American miracle of World War II was the incredible increase in production of war matériel. These items ranged from food and clothing to ships, tanks, jeeps, guns, and airplanes.

Newer, bigger, and faster warplanes were being designed. Building them required organization to bring together parts from suppliers, which were located in nearly every state and required transit by railroad. A host of components including tires, wheels, brakes, landing gear, gun turrets, life rafts, instruments, windows, and radios were purchased. Other parts were fabricated in back shops at the plant. They all came together in a process known as final assembly. Assembly line methods were borrowed from the auto industry. The finished products were towed to the flight ramp while awaiting any last-minute missing parts. After a minimum of two test flights, airplanes were ferried to their next destination.

Manufacturers faced an acute labor shortage when boatloads of workers marched off to war at the same time demand for warplanes skyrocketed. The solution was to woo women and people from other groups previously seldom found in aviation manufacturing. The strategy worked. New workers poured in from all walks of life. Some arrived fresh from school. Others came from agriculture, homemaking, retailing, service industries, and many other lines of work. They were drawn to the higher wages and better benefits, but the work could be difficult and dangerous.

With the deafening noise of constant riveting in many areas, an airplane factory can be a daunting, dangerous, and bewildering place for a new employee. Engines were test run and tuned before each aircraft was flight-tested. Flashing red lights warned of gunfire, which frequently crackled as heavy-caliber aircraft machine guns were boresighted and then test-fired into earthen pits. The need for expanded medical departments combined with enhanced employee-assistance programs evolved because long hours at work, combined with the stress of family members absent and gone to war, could push a person to tears.

Multiple off-site training facilities were established in the Greater Kansas City area even before the Fairfax buildings were completed. New employees were paid hourly rate as they were trained on aviation manufacturing skills while also being oriented on the rigors of factory work. The nationwide North American Aviation, Inc., wartime workforce swelled to 91,000 employees at peak and then plummeted to 5,000 in 1946 before stabilizing with the rapid development of jets for the Korean and Cold Wars.

The B-25 Mitchell quickly gained fame after Lt. Col. James "Jimmy" Doolittle led an audacious raid upon Tokyo when 16 Inglewood-built early versions (designated B-25B) of the medium bomber were launched on April 16, 1942, from the aircraft carrier *Hornet* then underway in the Pacific Ocean just east of Japan. The raid did little physical damage to Tokyo; however, it greatly boosted American morale and forced the Japanese to devote more of their military resources to defending their island nation. Most of the Doolittle raiders landed in China and survived. Doolittle was a hero, and annual reunions of the surviving raiders were a tradition that endured for seven decades.

Fighting a war is expensive. Treasury secretary and famed financier Henry Morgenthau was called upon to raise funds to fight World War II. Americans were encouraged to invest their excess money in war bonds. Another tool was for communities and other groups to raise funds to "buy a bomber." Larger donations purchased a heavy four-engine aircraft; lesser donations purchased something smaller—like a B-25. The Air Force Museum estimates that a B-25 cost $109,670 in 1943. At the start of the program, airplanes were adorned with the name of the contributing group painted onto the nose. The exigencies of war caused deception to creep into the program. At North American of Kansas, the ruse was carried out in the photographic department. A master photograph of a B-25 was prepared. Often, there was no serial number or other identifying marks. A calligrapher then inked the name of the contributing group onto paper. The image was photographed so the group name was then overlaid onto the generic negative. The resulting 8-by-10-inch photograph implied that there was an actual B-25 with white paint decorating the nose in celebration of the monetary contribution. Every group received a photograph of one of a few airplanes, and nobody at the factory bothered to dab a brush into a can of paint. Many people have attempted to research the combat fate of "their" bomber, only to be frustrated when told that no such airplane ever existed.

The B-25 Mitchell, small by today's standards, was the largest aircraft of North American Aviation, Inc., design in wartime mass production. The company left development of larger aircraft to others like Douglas, Consolidated, or Boeing. Fairfax produced two-thirds of the total of 9,884 B-25s that were built. Production figures include Navy PBJ-1s and all exported models. The initial Kansas City order was for 1,200 airplanes designated B-25D. As engineering improvements were made, production was converted to B-25J models. All other Mitchells were built at Inglewood, where development work was also accomplished.

By mid-1944, bomber assembly was halted at Inglewood after management was instructed to focus on P-51 production. The Fairfax plant was then the world's sole source of B-25s. They served with distinction in all facets of the war. The Mitchell was a new and state-of-the-art design in 1941. Rapid advances in technology meant that it was becoming obsolete as a frontline combatant by the end of hostilities; however, the B-25 remained viable for various military and civilian uses for many years because it was docile, reliable, and plentiful.

The North American Aviation, Inc., of Kansas photographic department was especially prolific. The large photographic collection was preserved. Most of the images document the manufacture, assembly, and testing of airplanes. When the photographers aimed their lenses at people and shifted the focus to work life, home life, and recreation, the result was treasure trove of human-interest pictures, which were stored away and only recently inventoried. It is our pleasure to share some of the best images from this time capsule.

One

NORTH AMERICAN AVIATION, INC.

During the 1930s, a consortium of aviation manufacturing companies was assembled with ties to General Motors (GM). Its heritage included sleepy East Coast airframe builders with names like Fokker and Berliner & Joyce. James Howard "Dutch" Kindelberger was recruited as the new chief executive, and he arrived at the General Aviation Manufacturing Company headquarters at Dundalk (near Baltimore), Maryland, in mid-1934. The name of General Aviation was retired, and the business was renamed North American Aviation (NAA), Inc., on January 1, 1935, with Kindelberger as president and managing director. Under Kindelberger's direction, NAA then evolved into a brand name and away from a holding company. He remained the driving force behind NAA successes until his death in 1962.

James Howard Kindelberger, who has been described as a man of shrewd judgment, with a generous sense of humor and a commanding personality, was born in 1895. He soon became known as "Dutch" and manifested the German traits of hard work, orderliness, and punctuality. At age 16, he dropped out of high school to become an apprentice steelworker. He soon came to despise foundry work and quickly turned his energies into getting the best engineering education obtainable. That education ended when he became a World War I combat pilot. After a postwar stint with the Glenn L. Martin Company, Kindelberger went to work for Douglas Aircraft and quickly rose to vice president of engineering before joining General Aviation in mid-1934.

The East Coast factories were abandoned, and operations were moved to Inglewood, California. With financial backing of General Motors, a major plant was constructed in 1936. Kindelberger attracted a lifelong entourage of talented people, and there was long-standing mutual loyalty between them. H.V. Schwalenberg was the first plant manager when the Kansas City factory was activated in 1941. The December 3, 1943, issue of *North Ameri-Kansan* reports that Schwalenberg was out on a six-week leave because of an unspecified illness. Harold R. Raynor, another member of the Kindelberger inner circle, replaced Schwalenberg. Raynor accomplished great things by the successful implementation of mass production techniques.

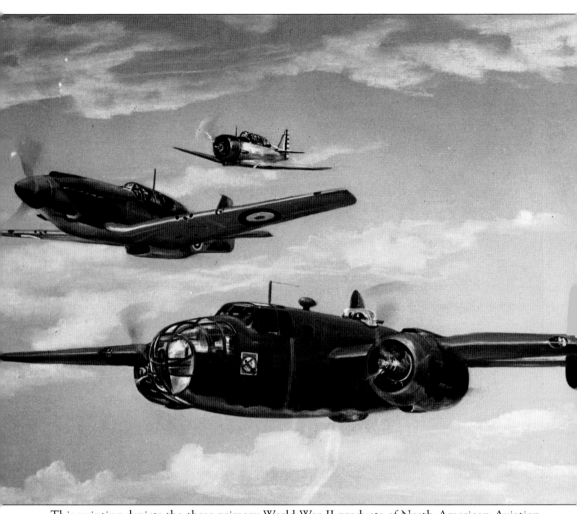

This painting depicts the three primary World War II products of North American Aviation, Inc. On top is an AT-6 Texan, a two-seat pilot-trainer aircraft; in the middle is a single-seat P-51 Mustang, a legendary fighter aircraft; and below is the iconic B-25 Mitchell medium bomber. All three models were considered top-notch, and many examples of each remain airworthy. North American operated three wartime plants. The headquarters was at Inglewood (near Los Angeles). Satellite plants, to help meet the wartime demand for aircraft, were established at Kansas City and Dallas.

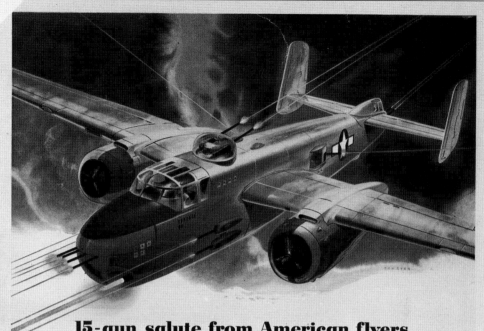

North American Aviation, Inc., had 30,000 stockholders. Like other companies during the 1940s, it ran advertisements in major magazines to inform the public of its contribution to the war effort. Three of the advertisements spotlighted the B-25 Mitchell. The series also touted other North American products to include the P-51 Mustang and AT-6 Texan. The Dallas plant also built about 900 B-24 Liberator bombers under license from Consolidated Aircraft.

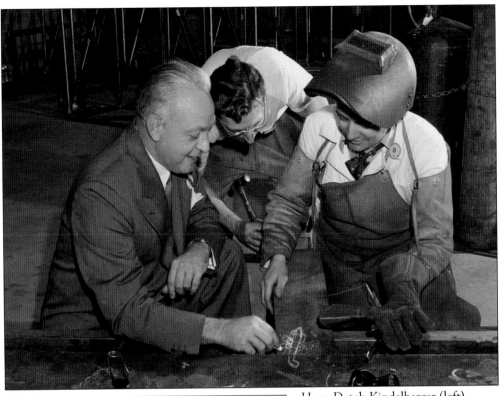

Here, Dutch Kindelberger (left) visits with workers at the Kansas City plant. Historians consider Kindelberger to be one of the "pioneers of aviation," along with Donald Douglas, William E. Boeing, James McDonnell, and the Wright brothers. Kindelberger is less well recognized than the others because the company did not bear his name. He and other executives traveled about the country in a special B-25 named *Whiskey Express*.

The North American logo adorned not only the impressive Art Deco facade on the end of the high bay and over the entrance to the main visitor lobby, but also the rudder pedals of the majority of the 40,000 airplanes assembled by the company between 1938 and 1945. North American built more aircraft during the World War II era than any other US company.

Two

EVOLUTION OF THE B-25

In 1934, the Army solicited proposals for a bomber to replace the obsolete Martin B-10. The North American contender was called the XB-21 Dragon. It first flew in December 1936, but lost the competition to the Douglas Aircraft B-18 Bolo; however, some of the best features of the XB-21 were carried forward into the B-25.

In 1939, another medium bomber competition was held—this time between the Glenn Martin Company and North American. Martin went to work on the B-26 Marauder, while the North American offering quickly evolved into the B-25 Mitchell. Because of the rapidly approaching war, both models were ordered into production. The B-25 design was approved by the Army on September 10, 1939, and the maiden flight was on February 25, 1941. Two men supervised the development of the B-25: chief engineer R.H. Rice and John Leland "Lee" Atwood.

An often-told tale is the genesis of the strafer version. The original design of the B-25 was as a medium bomber with a design capacity of 3,000 or 4,000 pounds of bombs. Guns were installed for the sole defensive purpose of fending off enemy fighter aircraft. In the South Pacific, a maverick pilot named Paul I. "Pappy" Gunn teamed up with North American Field Services representative John "Jack" Fox. Gunn was a retired Navy instructor pilot and American expatriate stranded in Australia by the Japanese onslaught. When the US Army found itself with an abundance of airplanes and a shortage of pilots, Gunn, at the age of 42, was field commissioned and assigned to fly combat. With the consent of higher headquarters, serviceable weapons from other wreck-damaged aircraft were installed in the nose of B-25 aircraft by Fox. Gunn invented tactics to use the machine guns with great success against enemy ships, ground forces, and airfields. He flew fearlessly at low altitudes and high speeds—which won him multiple medals for valor.

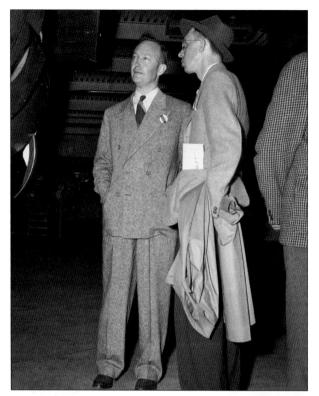

John Leland "Lee" Atwood (left) was the No. 2 man, after Kindelberger, at North American. He is seen meeting with a newspaper reporter at the Kansas City plant. Atwood was the chief engineer and had a major hand in the design of the B-25. It was Atwood who picked the name Mitchell for the B-25 in honor of Gen. William "Billy" Mitchell, an outspoken advocate of airpower between the wars.

Gen. William "Billy" Mitchell was another World War I aviator who advanced to assistant chief of the Army Air Service from 1919 to 1925. As an overly outspoken advocate of air power, he was court-martialed for insubordination. He was later vindicated but died at age 56 in 1936. The B-25 is the only airplane named for a person.

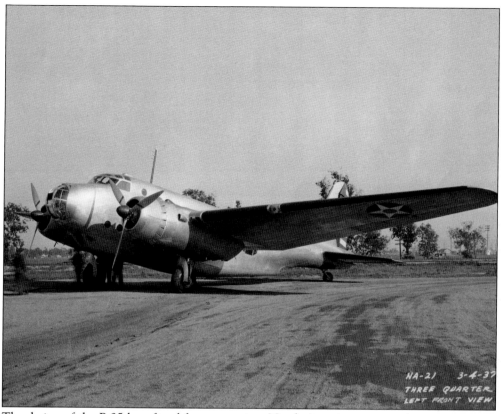

The design of the B-25 benefitted from a previous North American project that was a success but failed to win a production contract from the Army Air Corps. The experimental XB-21 Dragon first flew in December 1936. It pioneered many of the innovations that found their way into the B-25.

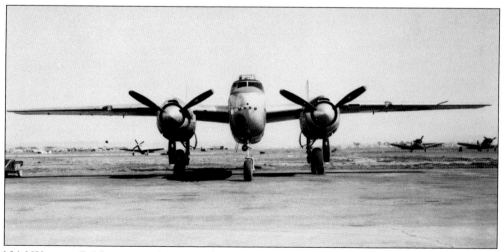

NA98X was a B-25 on steroids. It was the only Mitchell to receive a pair of significantly more powerful Wright R-2800 engines. Their presence is evident by the much larger spinner, the cone-shaped part, at the center of the propeller. Only one was built, and it was tragically destroyed by wing failure when the parameters of safe flight were exceeded on April 24, 1944.

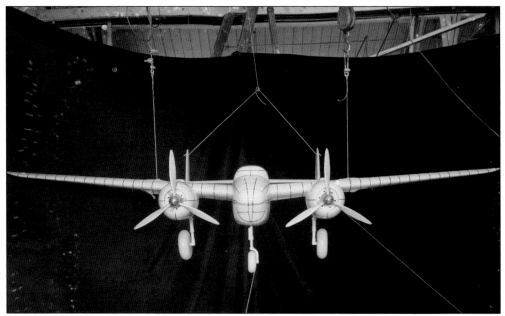

A 1/9th-scale wind tunnel model of the B-25 is readied for testing at the California Institute of Technology. B-25 development was accomplished in California. The early models were being flight-tested for further refinement as construction work commenced on a much-needed additional final assembly site—the Kansas City factory at the Fairfax Airport.

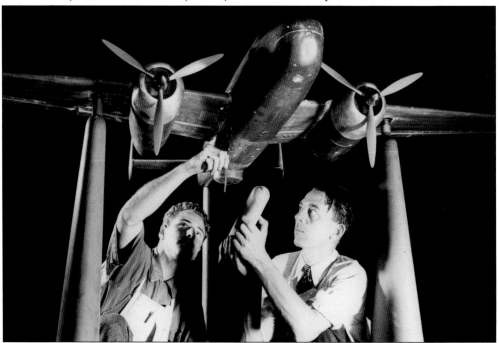

Technicians prepare to attach an external torpedo to a wind tunnel scale model. The arms, which secure the model, can be seen attached to the lower surface of each wing. Wind tunnel testing was invented by the Wright brothers, and it remains, to this day, an integral step of designing new aircraft.

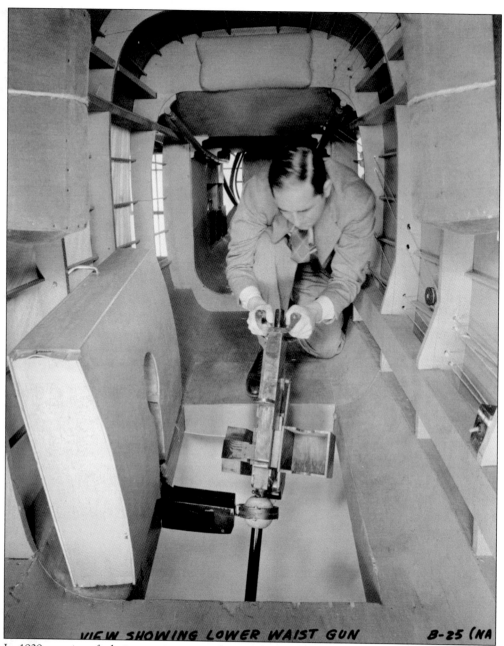

VIEW SHOWING LOWER WAIST GUN B-25 (NA

In 1939, an aircraft design engineer stands in a plywood mockup of the interior of a B-25 and demonstrates how a machine gun can be used to defend the craft during attack from below. Various guns, ranging in size from .30 caliber to 75 millimeter, were, at various times and various locations, installed on the Mitchell. The big nose-mounted, 75-millimeter cannons were built by Oldsmobile; however, most guns were .50-caliber versions from Browning. Bottom guns were eliminated starting with the first B-25G.

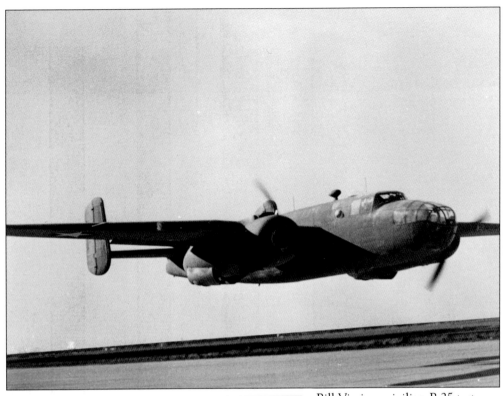

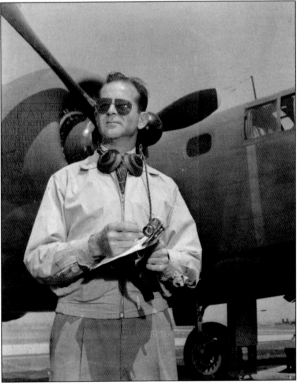

Bill Virgin, a civilian B-25 test pilot at Inglewood, California, is quoted in Norm Avery's *B-25 Mitchell: The Magnificent Medium* as saying that "North American hired me as a test pilot shortly after the first B-25 entered the flight-test program . . . It had already been discovered that with constant dihedral wings the airplane lacked the stability for bomb runs as desired by the Army. After the outer wing panels were flattened out to zero degrees dihedral the B-25 became an absolutely superb flying machine with excellent stability . . . Its 'settling' qualities were excellent. Control forces were well balanced and effective. I could set course, adjust power and trim and the airplane needed little or no attention even in relatively rough air. It was as forgiving as any airplane I ever flew."

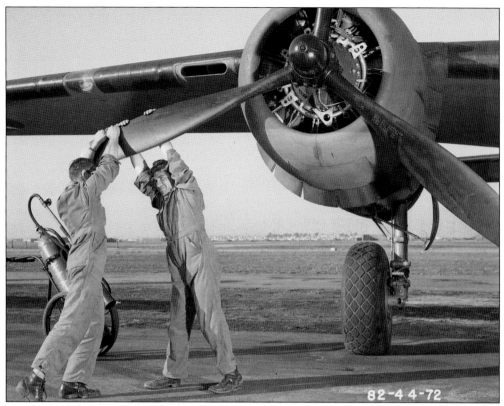

Here, two mechanics "walk the prop." The R-2600 radial air-cooled engines were loose when parked overnight or in the cold. Lubricating oil would then seep past the piston rings and puddle in the cylinders. Manually turning over the engine spreads the oil on the cylinder walls and ensures good lubrication on engine start. The metal expands as the engine heats up. The thousands of reciprocating and whirling parts then fit together nicely when at operating temperature.

The XB-28 was to be the follow-on medium bomber to the B-25. With more powerful R-2800 engines, it could achieve higher altitudes, which, in turn, dictated cabin pressurization for crew safety and comfort. The project was cancelled because the need for it had waned. One of the two experimental versions crashed during flight-testing on August 4, 1943. Crew members were able to parachute to safety.

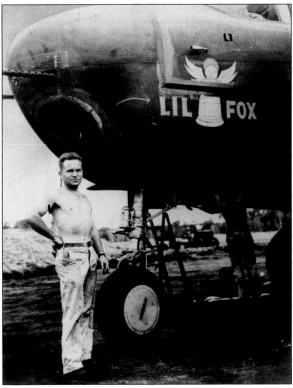

North American Field Services representative John "Jack" Fox is on the tug at a forward-operating base in 1942. In a stunning demonstration of American wartime ingenuity, he performed field modifications to add, for the first time, offensive firepower to this and other early B-25s. All subsequent factory-built "strafer" versions of the B-25 were the result of Army sponsorship and his specification package to the Inglewood factory, which was received in December 1942. The package provided drawings, photographs, and technical details of the work he performed. (Army Air Corps photographs.)

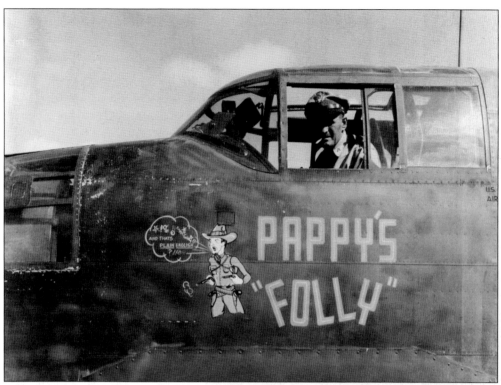

Paul "Pappy" Gunn, pictured above, was a 42-year-old retired Navy flight instructor and expatriate airline pilot stranded in Australia after he received a direct commission in the Army Air Corps. He developed the high-speed, low-level strafing techniques that turned the B-25 into a lethal ground-attack weapon. Gunn had a special hatred toward the Japanese because his wife, Clam Louise "Polly" Crosby, and their four children were incarcerated in the Philippines until they were liberated. A serious arm burn suffered in combat earned him a trip to California in 1945, where he toured, in uniform, the Inglewood plant accompanied by his recently released wife and Dutch Kindelberger.

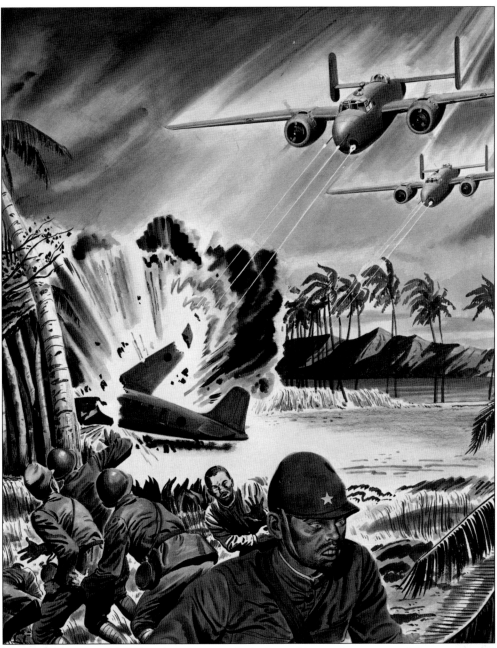

North American employed artists to create depictions of its products at war. The exaggerated and stereotyped renderings were typical of the genre and were intended to fuel the emotions of a country at war on two fronts. Renderings of the European theater were equally propagandized. This image portrays the type of air-to-ground attack that was developed by Paul "Pappy" Gunn. His story played out in 1942 but was kept under wraps until the safe release of his family was confirmed after the Japanese forces in the Philippines were defeated.

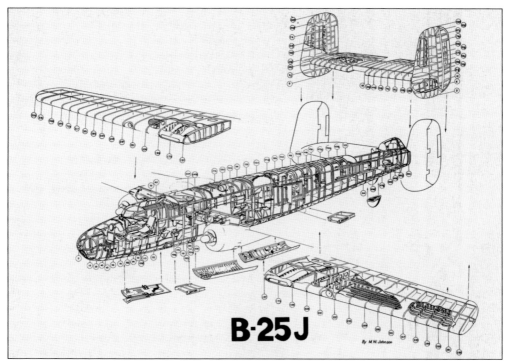

B-25J

By M.W. Johnson

The final step in the development of the Mitchell was the B-25J model. All of them were built at Kansas City, and they constitute a large percent of the survivors. Earlier models were too battle damaged, war weary, and worn out to be of value by the time hostilities ended. Exploded drawings assist in the organization of the assembly process and procurement of components.

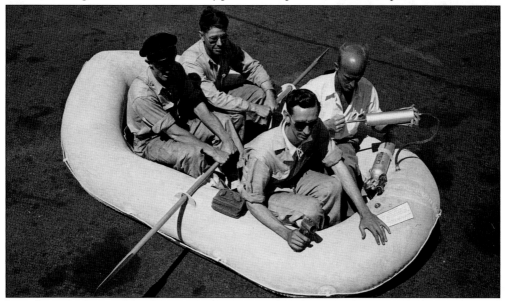

In a photograph staged for the maintenance manual, technicians demonstrate the attributes of the life raft. A carbon dioxide cylinder inflates the raft, and the hand pump will keep it fully inflated. The man on the right front holds a Very pistol, a breech-loading weapon that fires signal flares, while each of the pair in the rear grasps an oar.

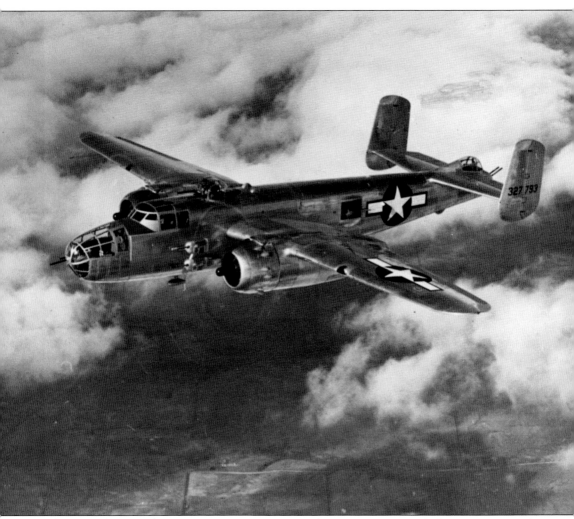

This in-flight photograph confirms that most of the structure of a Mitchell was aircraft-grade aluminum. Massive amounts of electricity were required to make all of the aluminum needed for nationwide aircraft construction. Fortunately, the 1942 completion of Grand Coulee and other dams made hydroelectric power abundant. Wartime metal shortages forced temporary substitution of wood where it could be utilized. Seats were a prime example. Later in the war, plastic was introduced for smaller, nonstructural parts.

Three

History of Fairfax Airport and Plant Construction

President Roosevelt stated that he "would like to see this nation geared up to the ability to turn out at least 50,000 planes a year"; therefore, on May 16, 1940, he asked Congress for a significant increase in defense spending. The Airplane Division of the National Defense Advisory Committee (NDAC) determined that massive expansion of factory space and workforce would be essential to achieve this goal. The visionaries on the committee included Army Air Corps leader Gen. Henry "Hap" Arnold and an auto industry executive William Knudsen. Knudsen was born in Denmark.

Up through the 1930s, airplanes were pretty much built one at a time, and this limited aircraft output. Meanwhile, automobiles were mass produced on assembly lines. Knudsen's role and challenge was to apply assembly line techniques to aircraft building. With an eventual sustained delivery rate of 300 units per month, Fairfax, along with many other World War II–era plants, achieved unprecedented rates of production.

The committee decided that new plants should be constructed in the middle of America. Multiple cities were selected so that housing, transportation, and other urban infrastructure would not be overwhelmed. The Kansas City plant would be located at an existing airport on the banks of the Missouri River in the Fairfax industrial district. It would be funded and built by the government to be operated under the name North American Aviation, Inc., of Kansas, which was sometimes abbreviated to NAA-K. Engineers and technicians at Inglewood were given a clean sheet to dictate the interior arrangement for the new factory. They made detailed specifications for procurement of all of the implements necessary for optimal B-25 production.

Consistent with aircraft plants then under construction in other cities, the plant was built of steel and concrete without windows so work could continue in blackout conditions. This made it necessary to air-condition the massive building. At that time, air-conditioning was an evolving technology, found more often in movie theaters than airplane factories. Constant temperature would minimize expansion and contraction of metal, thus ensuring better fit.

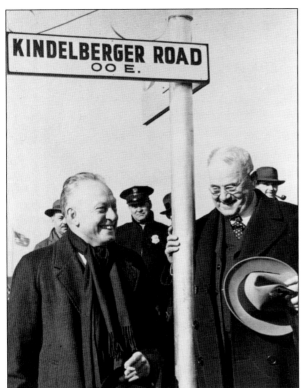

The governor of Kansas and 5,000 others attended the ground breaking for the Fairfax plant on March 8, 1941. Immediately after the ground-breaking ceremony, a Mr. Holcomb, who was chairman of the Wyandotte County Board, unsheathed a shiny new nameplate from a blue satin covering. With Kindelberger a surprised observer, Holcomb nailed the nameplate to a newly erected signpost. By April, a month later, 400 men were on the job as construction proceeded rapidly. Unfortunately, the spelling on the street sign was corrupted over the decades and now reads "Kind*l*eberger." Nobody has bothered to correct it.

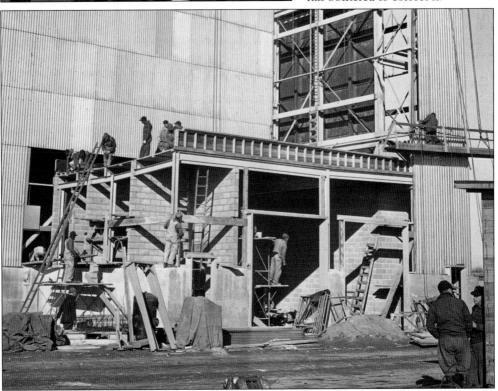

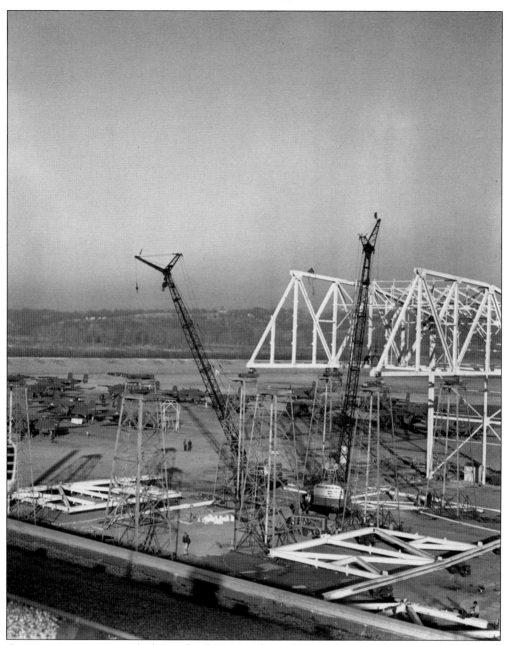

Construction cranes reach skyward as heavy steel members of the main factory are hoisted into their positions. The contract for plant erection was awarded to McDonald, Tarleton, and Patti of St. Louis and Kansas City. It shared project oversight responsibilities with the Army Corps of Engineers. Long wooden pilings, which looked like telephone poles, were driven deep into the ground and then covered with reinforced concrete. The sidewalls and roof were fabricated of sheet steel. North American took occupancy of the factory as final building construction tasks were wrapping up.

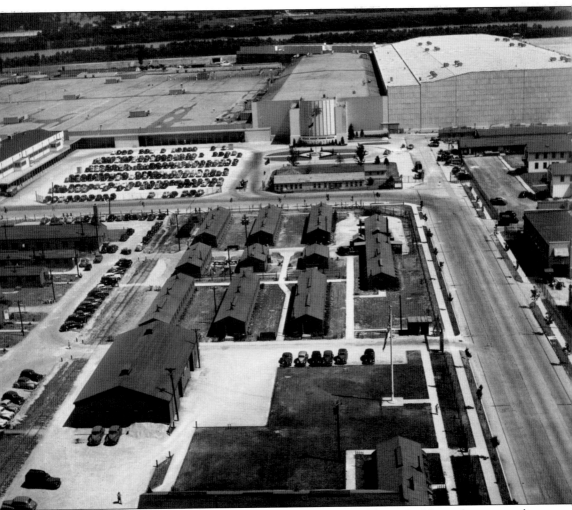

This low flyby view shows the many wartime temporary wood-frame buildings that sprouted at Fairfax. They were ubiquitous at most military bases and provided low-cost living and workspace that could be quickly constructed from abundant lumber by semiskilled labor without consuming very much scarce metal. The massive B-29 high-bay addition of 1942 is visible in the upper right-hand corner. Low-bay manufacturing spaces are seen on the upper left, with the Art Deco facade in the upper middle. Automobile parking lots and aircraft parking ramps consume much of the remaining real estate.

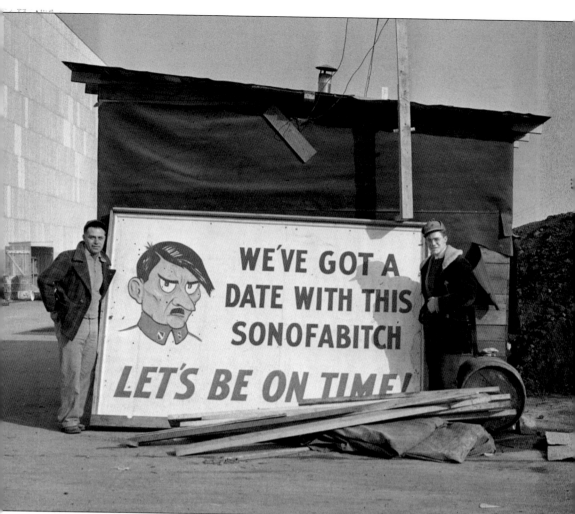

Wartime images frequently include graphics expressing ire and ill will toward the enemy. Some were directed across the Atlantic Ocean to the Nazis and Axis Powers, while others promised to avenge the Pearl Harbor attack in the Pacific Ocean. Both themes played upon ethnic and racial stereotypes. The Hitler sign at Kansas City was to motivate construction workers. Adequate facilities were an essential precursor for the successful manufacture of abundant war matériel, which was the hallmark of Pres. Franklin D. Roosevelt's promised "arsenal of democracy."

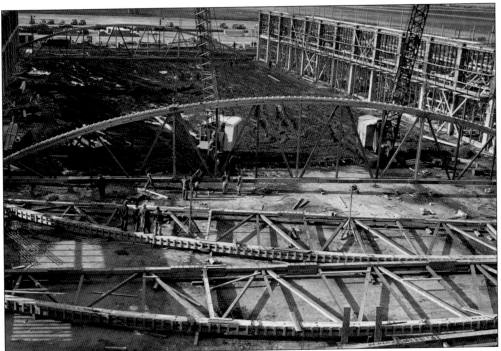

The Modification Center, built of wood because of a wartime shortage of metal, was distant from the main plant. All work was performed outdoors until construction was completed. B-25s were also flown in from Inglewood, and the large backlog of airplanes needing work is clearly visible. Transcontinental & Western Air (the earlier name of Trans World Airlines [TWA]) operated a separate modification center at the nearby Kansas City Downtown Airport.

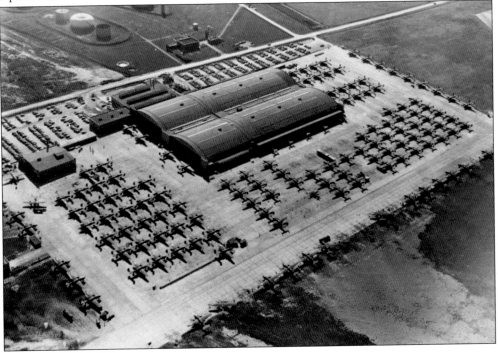

A B-25 is seen flying over the Art Deco high-bay plant facade. Kansas City–area business leaders, including Advisory Council for National Defense member J.C. Nichols, stressed the productive potential and loyalty of the citizens. Nichols argued that Kansas City was a "sleeping industrial giant" and an ideal location for an airplane factory. The visionaries had good reason to be proud of the result.

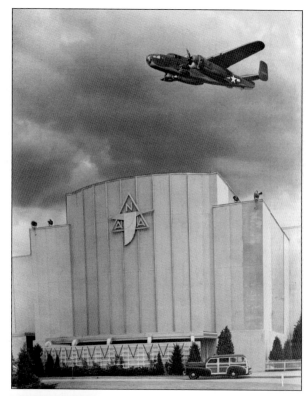

Adequate electric lighting was essential for round-the-clock operation in a building without windows. The "crow's nest" was a mobile tool invented for the purpose of replacing fluorescent lightbulbs. It could hoist a worker to the ceiling high above the factory floor. Individuals faint of heart or those with a fear of heights need not have applied for this job.

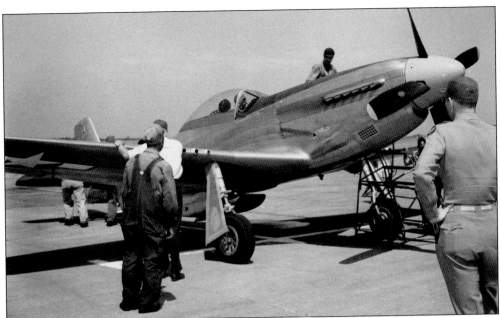

Many aviation historians consider the P-51 as the best fighter of World War II. They could accompany heavy bomber formations from England to Berlin and back. P-51 Mustangs were never assembled at Fairfax, but they were frequently seen at the Modification Center during 1945 when 118 of them were cycled through the facility.

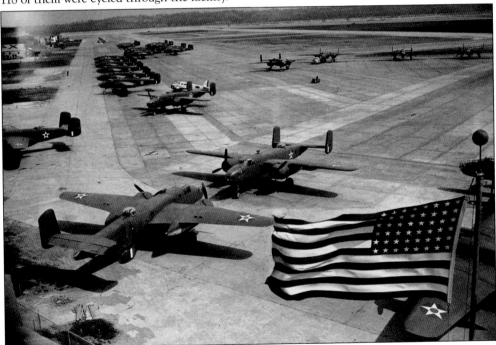

A flag flies over the tarmac at the Modification Center. After the Pearl Harbor attack, there was very little antiwar sentiment in America. It was a time of domestic harmony and common purpose seldom seen before or since. Patriotism was in vogue, and anybody harboring antiwar sentiments was wise to keep them hidden.

Four

GETTING PRODUCTION STARTED

A small cadre of executives and key technical people trickled in from Inglewood, California, during 1941. The first employees were hired and put into training starting in May that year. The parts and expertise to assemble the first six B-25s came from California. The government had contracted for an initial purchase of 1,200 B-25Ds to be built at Fairfax. During the first four months of 1942, only 11 airplanes were delivered. There were many startup problems, ranging from poorly fitting parts from the GM Memphis Fisher Body plant to developing the expertise of the new employees—the learning curve in aerospace manufacturing.

Two large expansions were undertaken early in 1942. The first was a Modification Center. It was located on a distant corner of the Fairfax Airport and fabricated mostly of wood, since wartime priorities dictated steel be used elsewhere. The second was a huge new rectangular high-bay hangar plus an outbuilding, which became the flight-test and armaments center. The new space was to be used for final assembly of the B-29 Superfortress—a big, fast, four-engine bomber aircraft then under development by Boeing. It was soon decided that B-25s were invaluable to the war effort, and B-29 production went elsewhere. The expansion added 370,000 square feet and another high bay that measured 350 feet in width, 1,060 feet in length, and over six stories in height. The space was quickly absorbed for B-25 production.

Airfield improvements were made. New runways were added, and old runways were extended until the longest one measured 6,500 feet. Acres of ramp parking space were paved. Ancillary structures were constructed over the course of the war to include a new firehouse, cafeteria, facilities for assigned military people, and a new control tower.

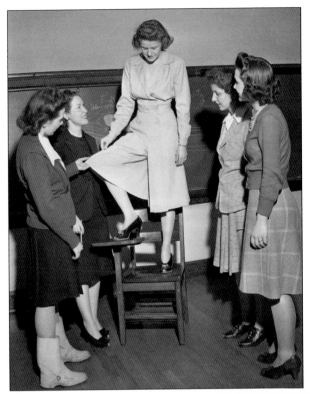

Women were seldom found doing factory work prior to World War II. Early in 1942, a style show was held to evaluate various female clothing options in the search for appropriate workshop attire. A one-piece coverall suit fabricated of denim was selected for the ladies assigned to shop work. It was stocked in the company store and sold for an initial price of $3.95. Mandatory wearing of the uniforms was dictated for a time; however, the initiative eventually faded because later workplace photographs show that the women, like the men, are wearing a variety of factory-appropriate clothing.

The original inscription on the negative sleeve is in the vernacular of the day and reads, "William L. Bryant, shop supervisor, receives the starting slips for the first two girls, Chloe N. Johnson and Louise Jasper, to work in the mechanical side of the shop, taking a man's job, which will in time be a common occurrence." The date is January 19, 1942.

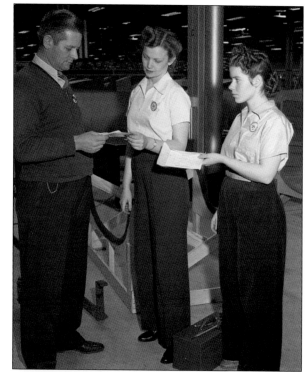

One of the earliest photographs in the North American Fairfax collection records a party for the engineering staff held on November 1, 1941. The location was the Spalding family farm located north of Kansas City. The theme of the party was agrarian, but the revelers' future endeavors were rapidly shifting to industrial. Even the horse looks happy.

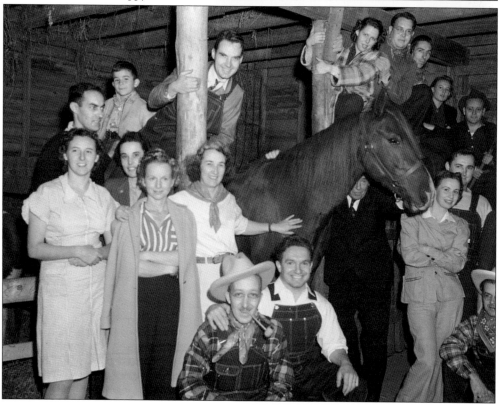

For those who did not live on nearby farms, government housing was provided. The Quindare Homes Federal Housing Project was completed in 1942. The 308 family units rented for between $58 and $62 per month. Pictured below, officials are in a frantic state immediately after the Pearl Harbor attack. The Kansas State Home Guard was called upon to defend the new Fairfax plant, still under construction, as the first airplane was in gestation on the factory floor. This photograph was earmarked for publication in the first issue of the *North Ameri-Kansan* when, at the last minute, the Army balked. The word *censored* occupies the rectangular space allocated for this image and its caption.

The plant was guarded 24 hours per day, seven days per week. A security tower provides an unobstructed view. The plant protection department also included a fire department, which was trained and equipped for response to not only plane crashes but also structural fires. Aviation gasoline is extremely volatile, making fire a constant risk around aircraft being fueled or started.

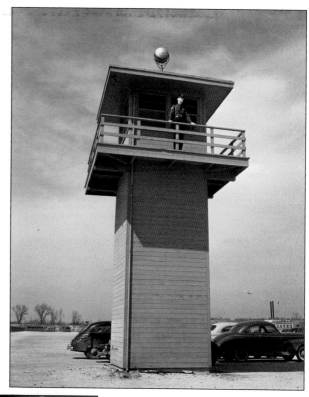

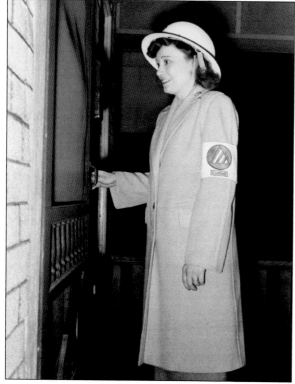

Bonnie Rockwell was an air raid warden. Kansas City was an unlikely target for an attack from the air since neither the Japanese nor the Germans were able to perfect a heavy, long-range bomber. After the war, air raid blackout shades were found in public buildings everywhere in America.

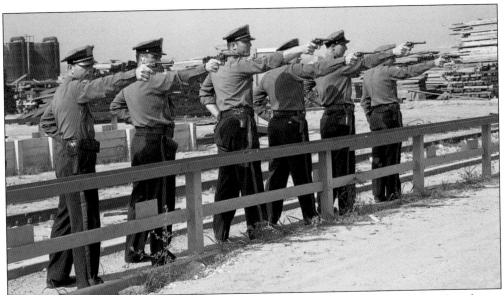

The uniformed civilian security force, which included both men and women, was referred to as plant police. The officers wore badges and crisp uniforms, carried pistols, and were taken seriously. Here, they are engaged in live fire at the pistol range to sharpen their marksmanship skills. Live-fire training was also conducted during hours of darkness.

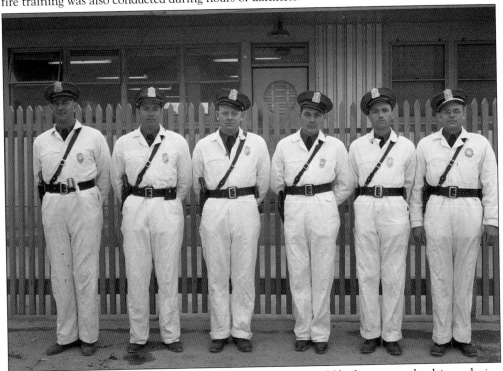

Police who directed traffic were outfitted in white so they could be better seen by drivers during times of diminished visibility. The short days of winter made it necessary for employees to arrive and depart during hours of predawn and dusk. There was traffic congestion at shift change because most employees worked the same schedule.

Sergeant Wilson of the plant police department (on a bicycle) talks with Officer George Brains. Some plant policemen were deputized and had law enforcement authority. Their mission was to maintain good order while protecting people and property from a variety of threats ranging from theft and trespass to espionage and sabotage.

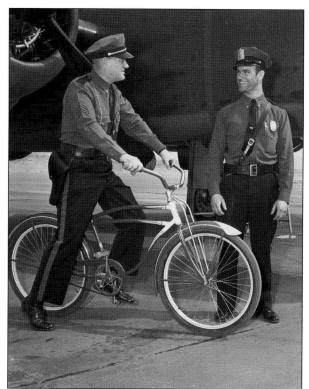

In the 1940s, technology like e-mail, text messaging, and cell phones was found only in science fiction. Telephone operators made the connections, and most calls were in-plant or local. Long-distance calls were expensive and infrequent. Telex operators at the plant utilized on-site Western Union equipment to transmit 300,000 words a month between other plants, suppliers, and the military.

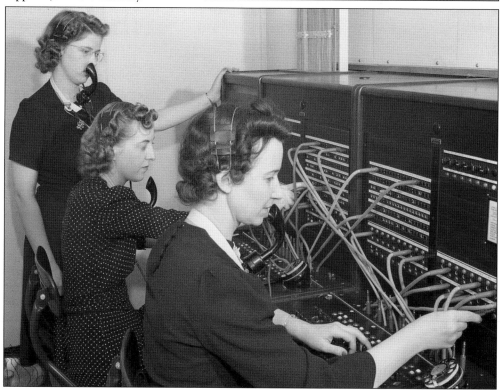

These students are learning to rivet at the Lathrop Training School in Kansas City, Missouri, under the watchful eye of an instructor. Multiple off-site locations were used to prepare prospective employees. They were paid an entry-level wage of 60¢ per hour while in training. The purchase of a modest package of hand tools for their personal use was required.

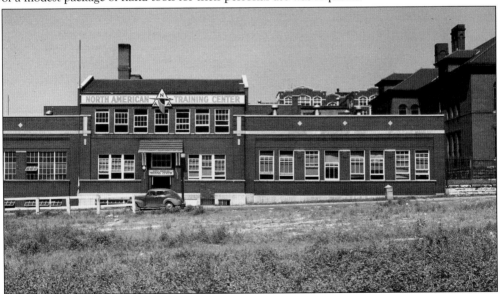

Employee training was conducted at multiple Greater Kansas City locations including the former Sumner High School, Argentine High School, and Manual High School. Off-site training locations reduced congestion at the main plant while putting existing underutilized buildings to a new use.

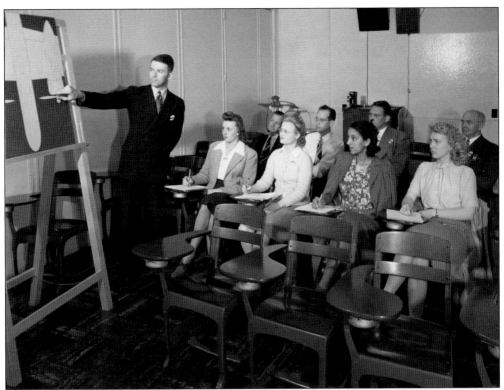

Nearly all Americans of the era were educated in the fundamental skills necessary for aircraft factory success—reading and mathematics. Life on the farm resulted in enhanced mechanical aptitude for many. Before arriving at the workplace, prospective employees could expect training in basic aircraft sheet metal work, blueprint reading, and shop math. These students are receiving classroom instruction that relates to the B-25.

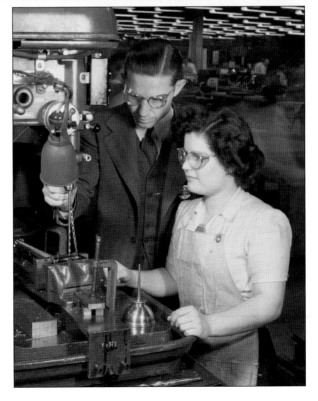

Proper training of new employees was an item of emphasis. The nattily clad instructor, in this case working in one-on-one mode, was held accountable if the student failed to learn. This trainee will be well prepared to take her place at a factory drill press after leaving the training facility.

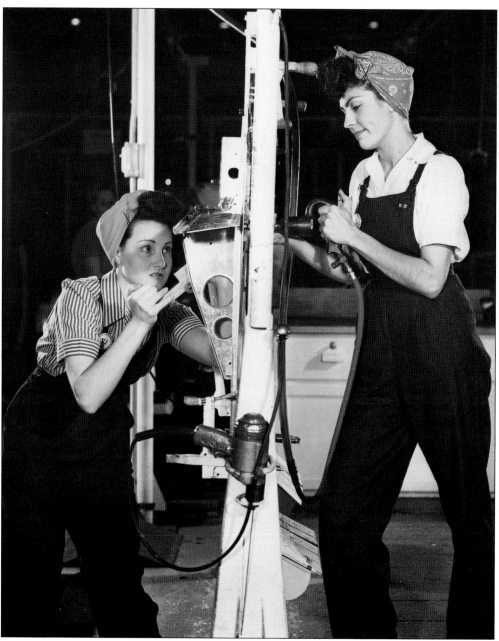

Riveting is a two-person activity. A rivet is installed in a predrilled hole. One person operates the air-driven hammer on the factory rounded end of the rivet while the other holds a heavy piece of metal so that the "bucked" end of the rivet becomes broader and secure. If done properly, the soft aircraft-quality aluminum sheet metal will not be dented. Alice (Huckleberry) Howlett and Ernestine (Bounce) Hargis are riveting a center beam. Alice, on the left, went to work at age 17 and later lived in Trenton, Missouri. Ernestine remained a resident of Kansas City, Kansas.

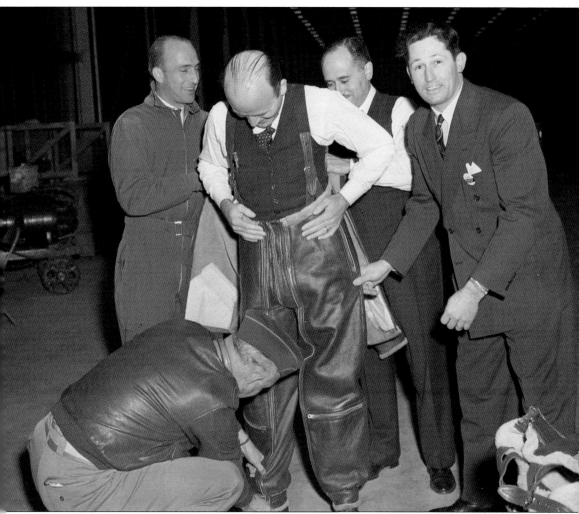

Plant manager Schwalenberg suits up for a frigid winter flight in a B-25. In this comical view, Maj. Leo Schlegle (kneeling), chief pilot Paul Balfour (left), an unidentified manager (second from right), and Superintendent Kelly (right) help him suit up in arctic gear. Surely "Schwally" would have drowned had his B-25 been forced to ditch into the icy Missouri River. Schlegle earned a degree in electrical engineering from Ohio State University and joined the Army upon graduation in 1917. He returned to the Army when his services were needed after managing a parachute manufacturing company between the wars. In a government-owned facility, the authority of the Army representative may well have exceeded that of the plant manager.

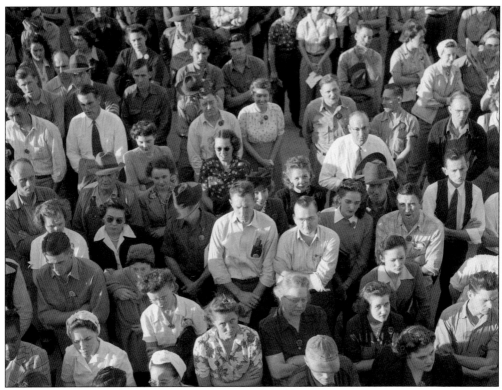

Training of the first 500 employees started in May 1941. At first, only white males between 18 and 35 years of age were considered. As this group marched off to war, anybody who could work was called upon to do his or her part. This included 16- or 17-year-olds who were not in high school, females, minorities, the elderly, and those with a handicap.

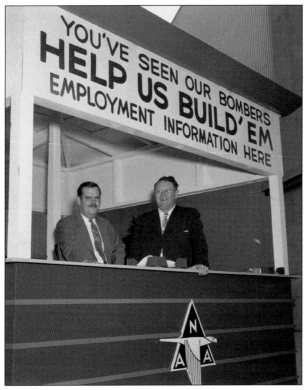

Recruiters at an open house demonstrate the ongoing need for more workers. There are no applicants in line waiting to talk with them. The serious unemployment problem of a decade earlier was a fading memory by 1944. The economy was booming, and there was full employment for all.

A new employee poses for a photograph that was taken on hire for use on the employee identification card. The identification card was to be carried by the employee at all times. Pins with department numbers were issued to be worn at chest height. They were to encourage employees to stay in their work areas and not wander about the entire factory.

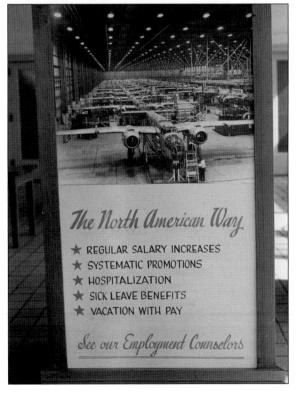

A sign enumerates the benefits offered to employees. Unfortunately, job security is not mentioned. Aerospace manufacturing has a reputation for being a roller coaster of mass hiring followed by mass layoffs, depending on the business cycle.

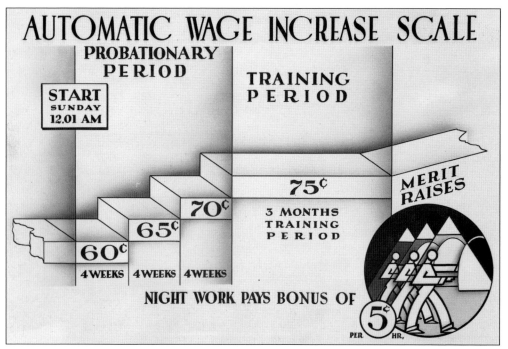

A graphic was prepared to explain pay rates to newly hired employees as part of their orientation. The rates were regulated by the government. Modest pay rate increases were authorized later in the war, and some of them were retroactive.

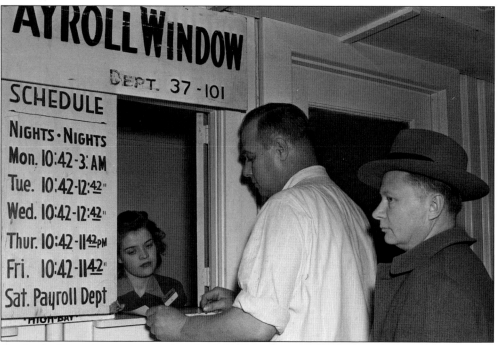

Paycheck discrepancies were to be adjudicated at the payroll department's employee service window. Most payday shortages were the result of the incomplete recording of all hours worked. Timekeepers gathered paper attendance records for validation before processing by payroll.

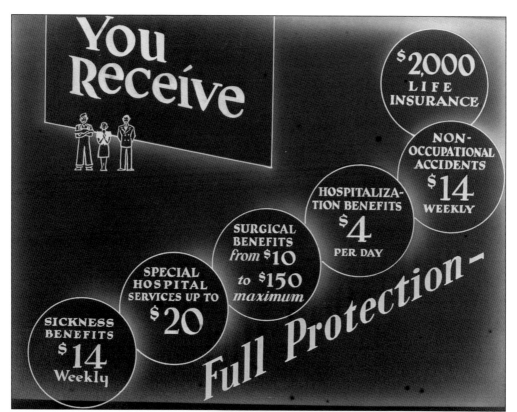

You
Receive

$2000
LIFE
INSURANCE

NON-
OCCUPATIONAL
ACCIDENTS
$14
WEEKLY

HOSPITALIZA-
TION BENEFITS
$4
PER DAY

SURGICAL
BENEFITS
from $10
to $150
maximum

SPECIAL
HOSPITAL
SERVICES UP TO
$20

SICKNESS
BENEFITS
$14
Weekly

Full Protection-

Employers offered health care and other benefits in order to sweeten the compensation package sufficiently to entice the much-needed workers. The tradition of company-sponsored health care started during World War II, when employers were forced to enhance the total compensation package because of government-imposed wage limits.

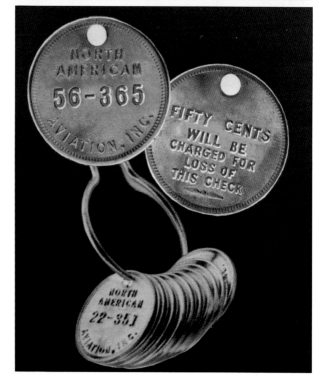

Mechanics were expected to buy and maintain their own small hand tools. Bigger or more specialized items were drawn from the tool crib. Chits were issued to the mechanic for exchange when a specialized tool was needed. The crib attendant then knew who last borrowed the item.

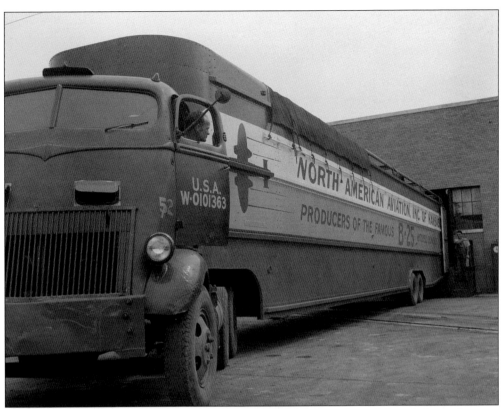

Above, four of these behemoths were utilized to move parts from the local General Motors Leeds warehouse to the North American plant. The trailers, measuring 65 feet in length, are painted red, white, and blue. Airplane parts are light but bulky. The tractor has two engines; one engine powers each of the two drive axles. The driver is Ames Edwards, while Ernest McMahan directs him from the rear. The attire of those pictured at left suggests that the two men also perform work related to motor vehicle maintenance and/or operations. The man on the right is holding a motor vehicle bottle jack. The flight-test truck is most likely in the motor vehicle shop for servicing.

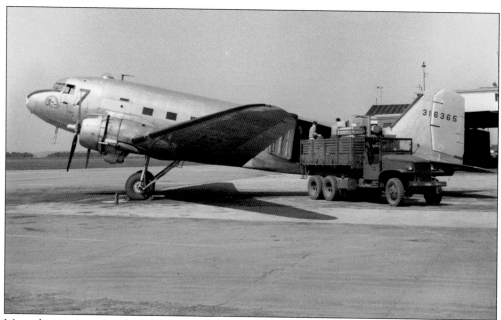

Most shipments arrived and departed by rail. An average of 500 carloads were received, and 300 carloads departed Fairfax every month. Outbound freight consisted of spare parts, reusable shipping containers, or scrap. A high percentage of the aluminum ends up as scrap in the normal course of business at an airplane plant. Airfreight, as shown here, was infrequent. The aircraft is a Douglas C-47, the military version of the DC-3.

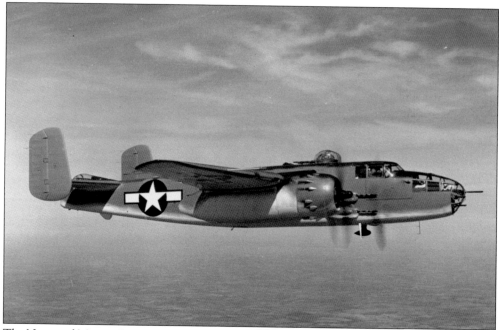

The Navy and Marine Corps designation for the B-25 was PBJ-1. The Navy used many as submarine hunters. Others went to the Marines. The "PB" stands for "patrol bomber," "J" is the code letter for North American Aviation, Inc., and the letter after the "1" is the model number. The Army Air Forces would designate a Marine PBJ-1J as a B-25J.

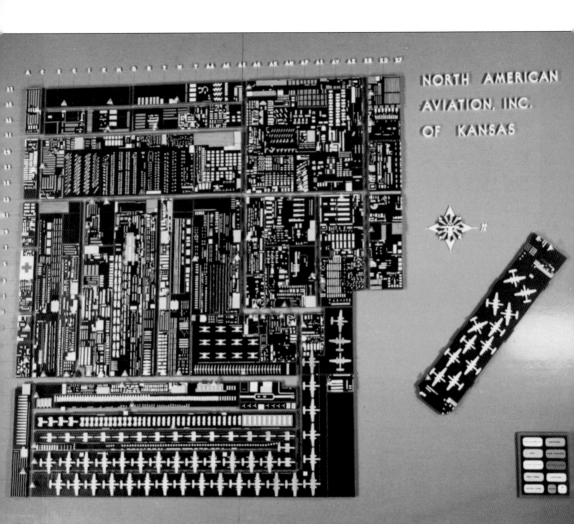

A schematic was maintained to document the Kansas City factory arrangement. The layout of an airplane plant is subject to frequent change. The original plant flow was sketched out at Inglewood before the Fairfax plant was constructed. The windfall of additional floor space, resulting from the B-29 expansion, triggered a massive rearrangement of the factory. The overarching goal at Kansas City was to maximize production, and industrial engineers earned their living by perpetually tweaking, simplifying, and improving the work flow.

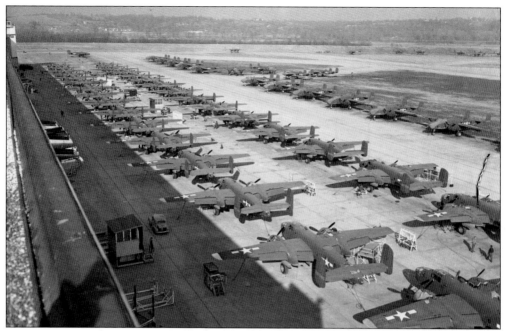

The War Production Board set quotas for critical matériel, which sometimes resulted in unfinished airplanes going out the door and sitting on the shortage line east of the high bay. When the missing parts arrived, they would be properly installed. Long lines of airplanes parked nose-to-tail are symptomatic of parts shortages, out-of-sequence work, and an unhealthy factory.

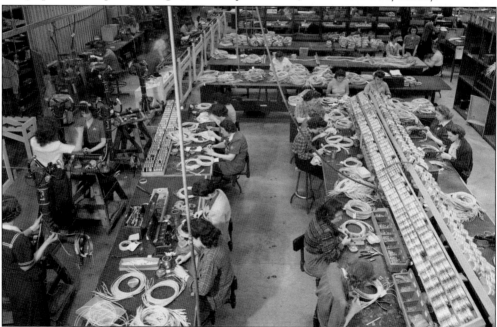

Workers are seen fabricating wire bundles that tie all of the electrical components of an airplane together. Fabricating wire bundles is done in the wire shop. Women have traditionally dominated the workforce because it is light work that demands superior dexterity. Aspects of it have since been automated.

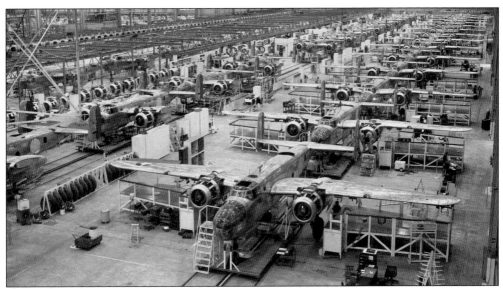

These are memorable views of the assembly line from April 1944. People are at work, but they are too small to be readily discerned. The bare metal of the skin makes the planes look all the same. After leaving the factory, they are taken to the paint hangar for washing and application of external markings, including insignia and the serial number, which was applied to each of the vertical tails. Combat crews, if they wished, could later apply nose art. Most airplanes spend their lives either in flight or parked on the flight ramp. Only occasionally are they brought into hangars for inspection and maintenance.

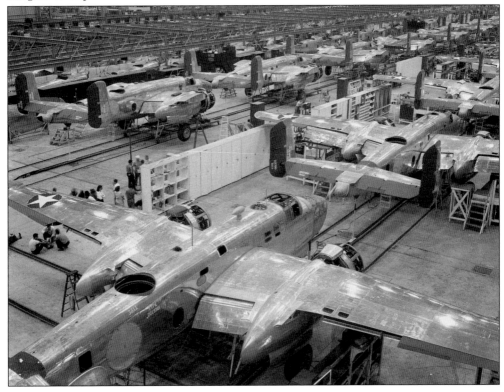

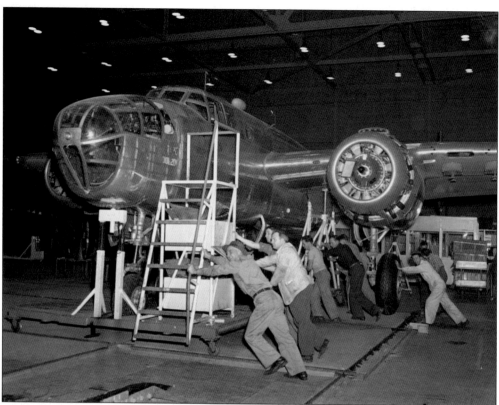

The assembly line shifted from nose-to-tail to wingtip-to-wingtip near the end of the final assembly process. These mechanics demonstrate that human power alone is sufficient to move the airplane along. Since the airplanes were on rollers, they could continue along the process even if certain components were unavailable. The sideways movement ended when the factory doors were reached. The newly assembled B-25 would find itself exposed to sunshine for the first time as a tow bar was attached to the nose landing gear for tug-powered movement to an available parking spot on the flight ramp. At peak production, multiple B-25s would pass through the exit door every day.

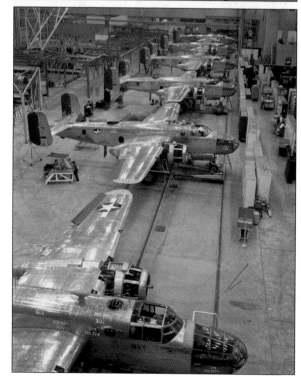

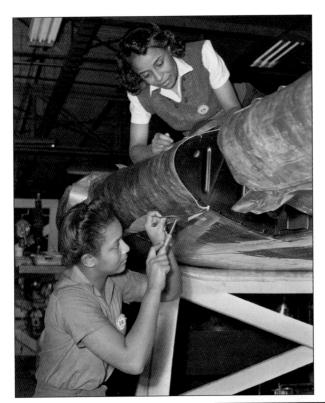

People working indoors were attired about the same at all times of the year, which means the air-conditioning must have been adequate to maintain a stable temperature in all seasons. Iris Mahone (left) and a coworker are seen collaborating on a task.

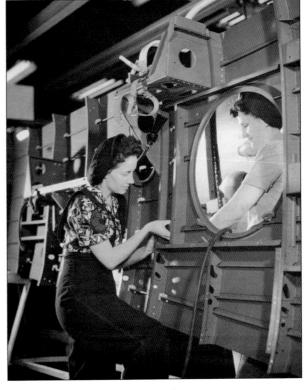

Riveting is an essential but extremely noisy task. The hallmark of a busy airplane factory is the rat-a-tat of many simultaneous riveting operations. The use of eye protection was encouraged, but photographs reveal that the use of eye safety goggles was spotty.

This employee is being fitted with earplugs. Hearing protection is important in a noisy work environment, but the wearing of eye protection received more emphasis. Avoiding work-related hearing loss remains an industrial emphasis item.

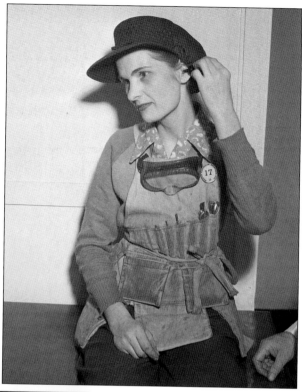

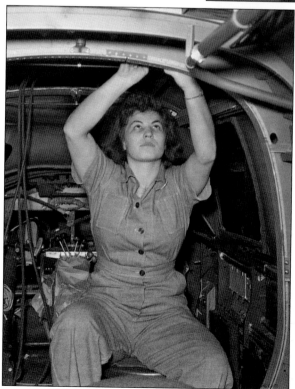

Vivian Uehling is working inside a fuselage on December 10, 1942. She is wearing the prescribed female shop attire. The government operated multiple day care facilities in Greater Kansas City. Children ages two through six were welcome.

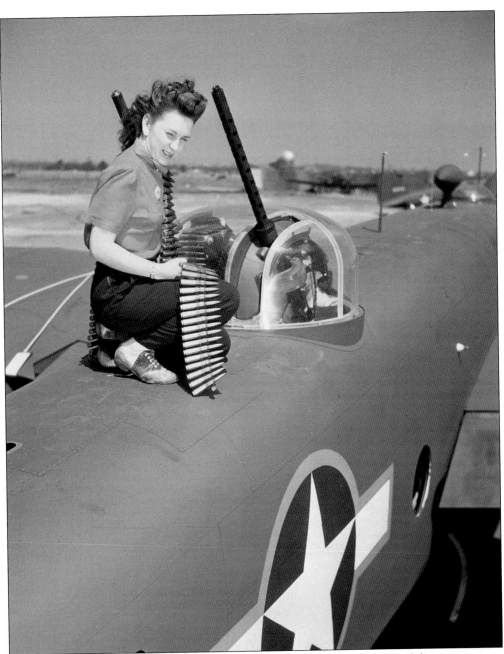

Bendix manufactured the top turret. Every Browning machine gun was loaded with live ammunition and test-fired. The largest number of .50-caliber guns installed on a B-25 was 18. Caution is required when climbing on airplanes. The top of the fuselage can be extremely slippery when wet or icy, and a fall to the concrete below could result in serious injury. In today's environment, this worker would be in a tethered safety harness. With a large and inexperienced workforce, it is amazing that (to date) not a single instance of accidental discharge of a weapon or related injury has been uncovered.

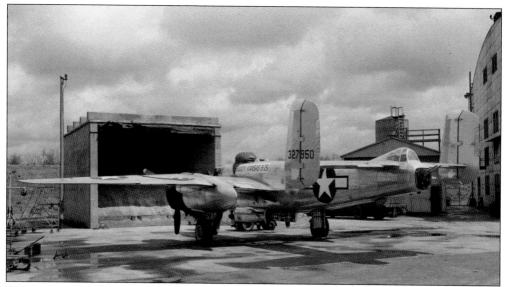

Two concrete bunkers, measuring 27 by 37 feet, were installed on the Missouri River levee and filled with sand. The bombardier's compartment was replaced with machine guns on the strafer version of the B-25. Aircraft-mounted guns were boresighted and then test-fired into the bunkers. The wheels are heavily chocked to prevent recoil from rolling the aircraft backwards. With 12 forward-facing guns, a strafer could deliver half-inch .50-caliber slugs at a rate of 9,000 per minute. This amount of airborne firepower would be formidable in any war. A minimum of 25 rounds was put through every gun before they were dismounted, cleaned, wrapped, and re-stowed in the aircraft before delivery. The sand was replaced every two weeks because the bullets pulverized it into fine dust.

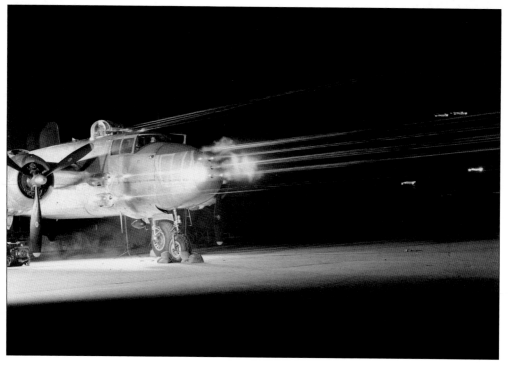

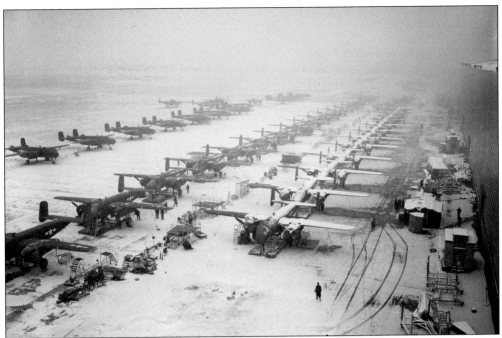

The simultaneous arrivals of cold, wind, and snow combine to make working outdoors in the winter on the Great Plains a miserable experience. Unfortunately, many essential aircraft maintenance tasks, such as refueling, testing the radios, servicing tires and brakes, trimming the throttles, engine repair, and a host others, have always been done on the tarmac. The interior of an airplane can be expected to be ice cold in the winter and stifling hot in the summer. High winds can render an airplane mobile when it should be static, thus making tie-down ropes and steel anchors set in concrete necessary to secure it.

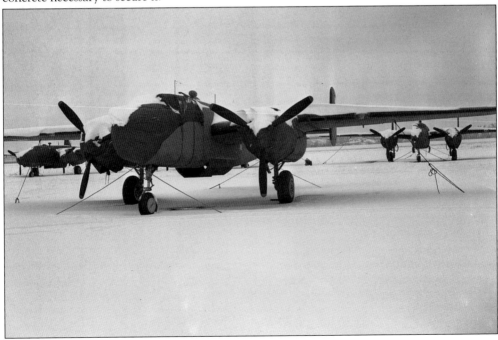

Employment at the Fairfax Airport facilities peaked at over 24,000 in late 1943. With Schwalenberg on sick leave, Harold Raynor was the acting plant manager. On November 11, he sits on the flight ramp in the midst of a blizzard and ponders achieving ever-increasing production quotas in spite of the numerous challenges facing him. Plant manager seems an inadequate job title as compared to his responsibilities. Raynor is credited with sponsoring numerous innovations that brought aircraft production rates to levels never anticipated nor seen since. Production results were prominently posted for all to see. Tail assemblies can be seen on the ceiling-mounted moving conveyor.

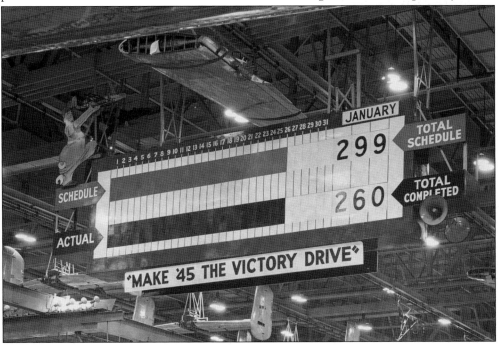

This March 5, 1942, image finds plant manager Schwalenberg on the left, while Maj. Leo Schlegel, the Army plant representative, is on the right. In the center is newly minted Lt. Gen. William Knudsen, who was born in Denmark and became an auto executive at Ford Motor Company and then General Motors. In 1940, Pres. Franklin Roosevelt invited Knudsen to come to Washington, DC, to head up the mobilization of industry effort undertaken in response to expanding warfare in Asia and Europe. In January 1942, Knudsen was commissioned as a lieutenant general in the US Army, and he was the only civilian to join the US military at such a high rank. He was a frequent visitor to Fairfax and other wartime defense plants.

Five

VISITORS AND
IMPORTANT EVENTS

The photographic department at the North American Kansas City plant was especially prolific. The editors of the two company publications, the *America-Kansan* newspaper and *Skyline*, combined with the public relations department to fuel a voracious appetite for newsworthy or compelling human-interest photographs to illustrate their stories.

The important and the not-so-important visitors were photographed. Military members were expected to wear uniforms even while off duty. Any visit from those in uniforms, along with recreational activity or sporting team, was fair game for a photograph. Two of the most memorable events were the presentation of the Army-Navy "E" Award (for excellence) on October 6, 1944, and the presidential visit by Harry S. Truman on June 27, 1945.

The Army-Navy "E" Award went to less than five percent of eligible providers. Quality and quantity of production are the factors that were given the greatest weight in selecting recipients. Other factors considered included overcoming of production obstacles; avoidance of stoppages; maintenance of fair labor standards; training of additional labor forces; effective management; safety records, health sanitation, and plant protection; and utilization of subcontractors. Procurement officers made nominations to an award board. The board evaluated the nominations and selected the winners. Each Fairfax employee at the time of the award received a special pin to proudly wear. Some of these pins, no doubt, can still be found tucked away with other treasured mementos in a few Greater Kansas City–area homes.

Harry S. Truman was a product of the Tom Pendergast Kansas City political machine. He became president on April 12, 1945, upon the death of Franklin Roosevelt, who had been in declining health for many months. Truman was reared on a nearby farm and served in the US Army Artillery Corps during World War I. According to the Truman Library, he arrived at Fairfax Airport because the Secret Service preferred that he not use the main Kansas City airport. It was his first visit home after assuming the presidency. He spoke at the Kansas City Auditorium to a packed house and was entertained at a luncheon by his law class at Kansas City University.

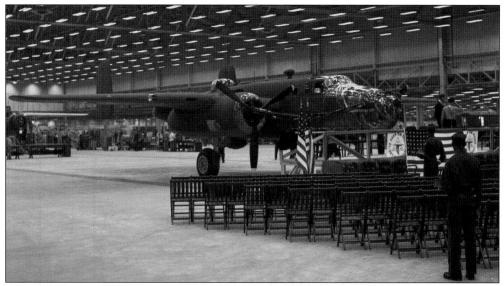

The number one Fairfax-assembled airframe, dubbed the *City of Greater Kansas City*, awaits dedication by Mrs. Thomas L. Bender, spouse of the first person on the assembly line. She smashed a bottle of bubbly over its nose on December 23, 1941. There was probably a piece of steel pipe or angle iron hidden under the clear wrap. Airplanes are fabricated of aluminum, the same soft metal used in soda and beer cans. A stout champagne bottle can do serious damage to the delicate structure of the bombardier's compartment. A much larger planned celebration was scaled back in reaction to the then recent Pearl Harbor attack. The aircraft's maiden flight was in January 1942. Because of startup woes, the plant struggled to deliver only 11 aircraft in the first four months of 1942.

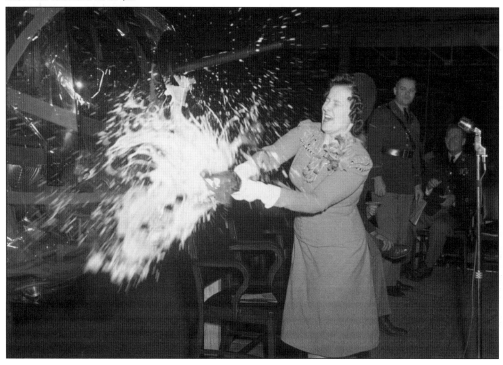

Frances Perkins stopped briefly to watch John Hadden make adjustments to a propeller. Perkins, the first woman ever to be appointed to a presidential cabinet, was the secretary of labor from 1933 to 1945. "These plants are wonderful," she said, "and I am glad to see a lot of older men, as well as women, doing a fine job for the war effort."

A lunchtime pinochle game is recorded in the photographic department. At least one of the photographers was not a participant but may have used his lofty perch to see who held the best hand. The photographers were professionals and dressed nicely. North American had all of the resources necessary to create and publish aircrew training and aircraft maintenance manuals, plus other documentation.

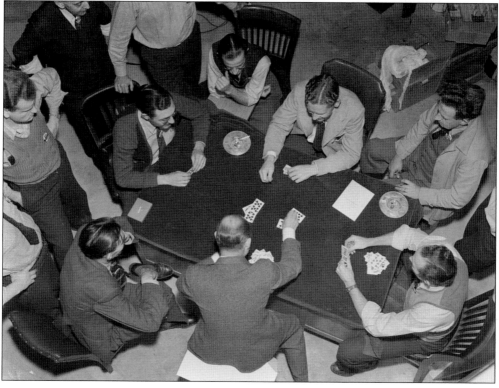

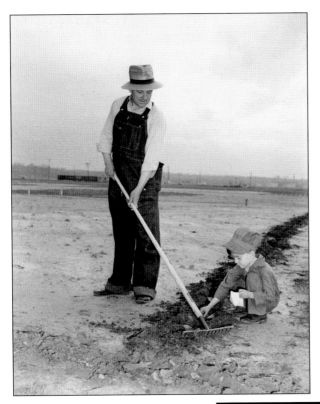

A victory garden was established on rich farmland owned by the Union Pacific Railroad. It was located west of the parking lot on Kindelberger Road. Each year, after it was plowed, the recreation department divided it up into 50-by-100-foot plots for the 350 employees who applied for space. The youngster is Dick Hart, and he is helping his maternal grandfather, Guy Lee, by sowing seeds. The date is May 2, 1945. All Americans were encouraged to grow their own food during the war. Many forms of recreation were company sponsored, including ice-skating at the Pla-Mor Rink.

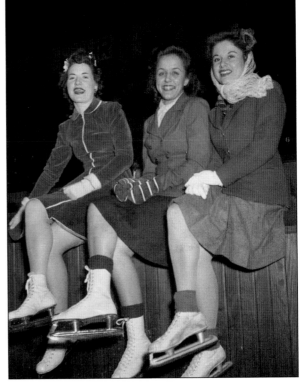

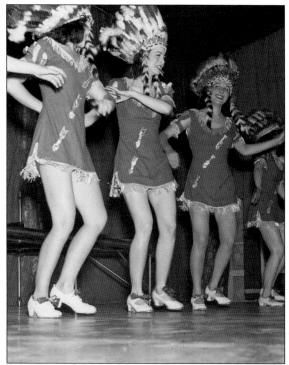

When the factory opened, everybody was challenged to learn his or her job and speed up production. After time, boredom could set in as the work became routine. Entertainers were brought in to maintain employee morale. By 1945, an area in the factory was designated the "Hi-Bay Bowl," and live performances by big-name acts of 32-minute duration were scheduled at lunchtime every Tuesday and Friday. This performance, with female dancers in Native American attire, may be the "Brush Creek Follies." The crowd visibly demonstrates its approval.

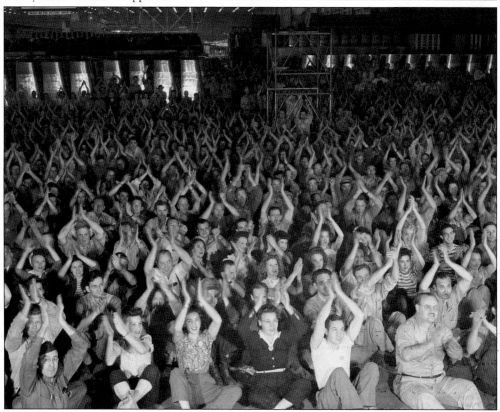

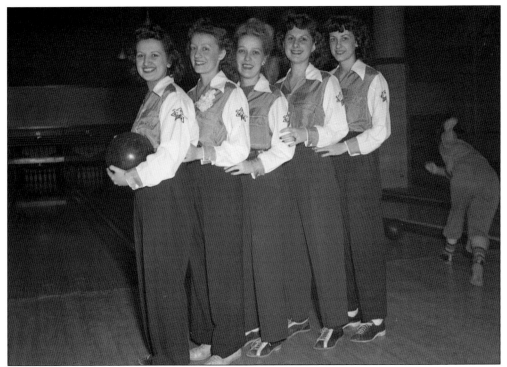

Bowling has always been a popular form of indoor exercise, friendly competition, and social interaction. To serve the needs of not only the younger but also the older adults on the payroll, the recreation department aggressively sponsored many forms of activity necessary for the physical and mental well-being of the workforce—while abiding by the constraints of wartime shortages.

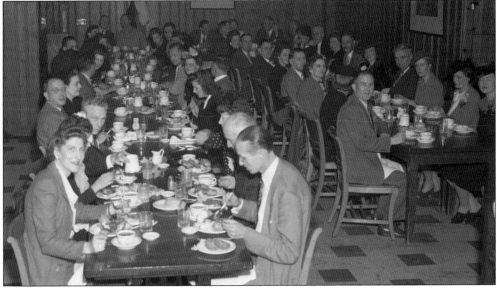

The nature of the event is unclear, but the location is the Pine Room at Union Station. Union Station was the hub for military and other people arriving and departing Greater Kansas City. Airplanes need airports, and airports are usually located on the fringes of urban areas; therefore, North American did not have a downtown presence.

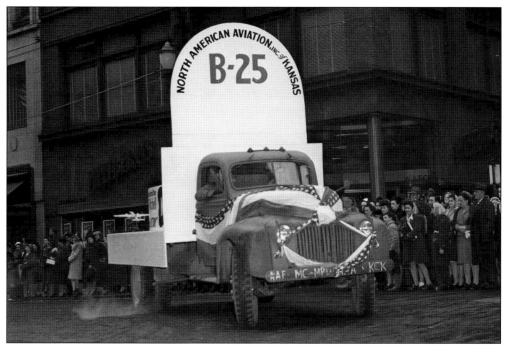

A well-used Army truck that has been modified into a parade float is seen rounding an urban street corner. Ice on the pavement, as well as other clues, tells that it was a cold-weather event sometime between Thanksgiving 1944 and New Year's Day 1945. The plant strived to be a good citizen of the community.

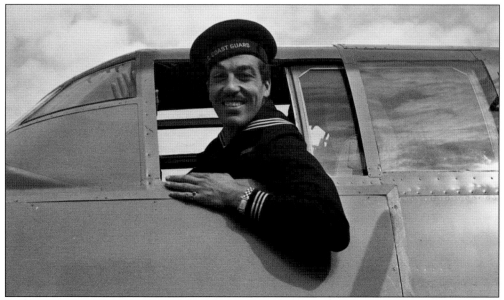

Entertainer Cesar Romero visited the plant on November 1, 1944. He was an enlisted member of the Coast Guard and a combat veteran. The *North Ameri-Kansan* reported that as part of his live stage presentation at Fairfax, Romero stated, "Every man and woman working at a war plant is fighting this war with every soldier, sailor, marine, and coast guardsman, as much as if he had a gun in his hand."

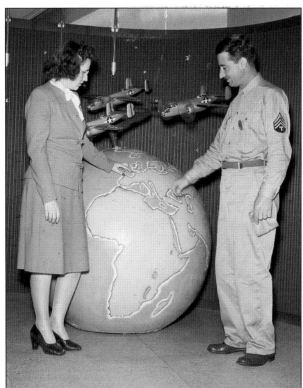

Former prisoner of war (POW) Elmer George points out to his wife, Nell, the site of his incarceration in Germany. The couple is looking at the globe that was the centerpiece of the main reception lobby. Sergeant George was taken prisoner during the Battle of the Bulge in December 1944 and was forced to march for 41 days before being liberated from a POW camp by US Army forces on April 13, 1945.

On at least three occasions, a B-25 was towed downtown for public display. The outer wings were removed for towing and then reattached when the Mitchell arrived at Kansas City Union Station. The movements were scheduled for hours of darkness to avoid daytime traffic. Aircraft are seldom moved over public streets.

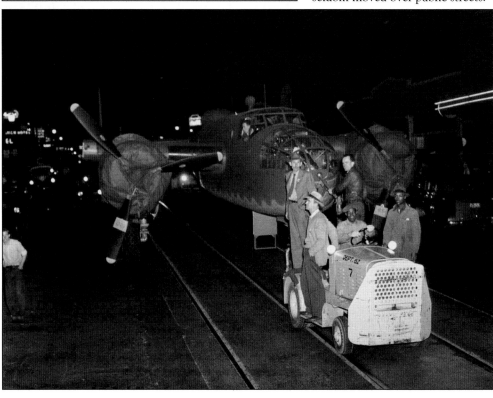

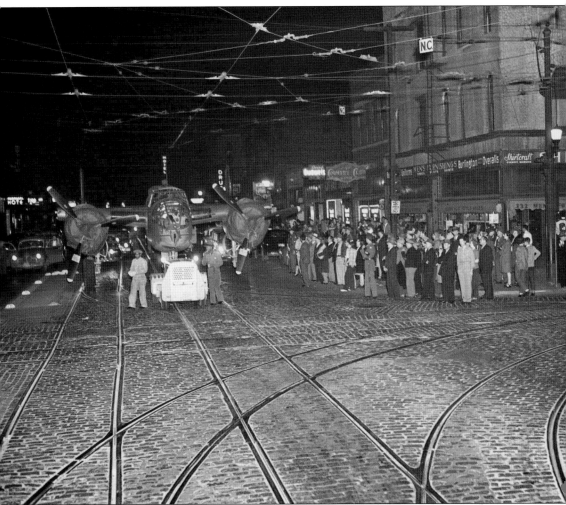

Public display of a large locally built warplane was a source of pride for plant employees and their families. An airplane not in flight or at an airport is always an attention grabber, and since airplanes were in sufficient supply, the Army Air Corps could spare one for a few days. The towing of a B-25 from the Fairfax plant to downtown was a good way to advertise for the sale of war bonds; to recruit and attract new workers; and, in the final instance of a B-25 being towed downtown, to create a display for Gen. Dwight Eisenhower's motorcade.

The plant newspaper was called the *North Ameri-Kansan*. It was published every Friday from December 1941 through August 1945. The standard fare included tales of B-25s in combat, human-interest photographs, news of sporting events organized by the recreation department, and other updates. Another company publication was a magazine called *Skyline*, which covered bigger issues. It was distributed at all three North American plants—in Dallas, Inglewood, and Kansas City. American citizens followed wartime events with great interest. Flight ramp mechanics are reading the late-breaking details of the Normandy D-day invasion in a newspaper dated June 6, 1944. They were unaware that General Eisenhower was being transported back and forth across the English Channel in the modified B-25J they had built.

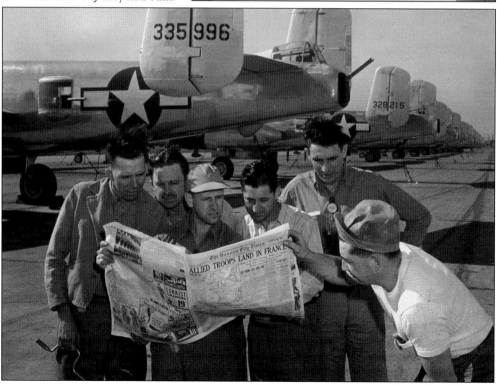

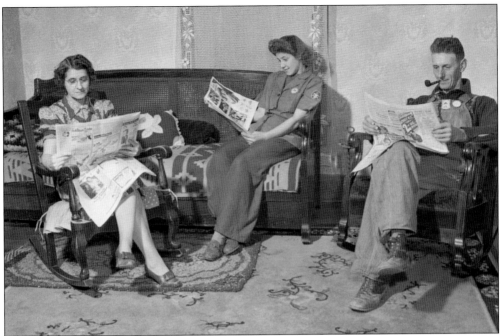

Eleanor Oelsheleger was featured in a *Skyline* magazine article. She lived with her parents on a nearby 160-acre farm and rose early to milk the cows. She drove a tractor and fed chickens on her days off. By day, Eleanor installed brake lines, oxygen tubing, and oxygen tanks on B-25s. In a world torn asunder by war on multiple continents, and whether intended or not, the photographs convey to posterity that Americans were better fed, better housed, and better dressed than the citizens of most other countries of that era.

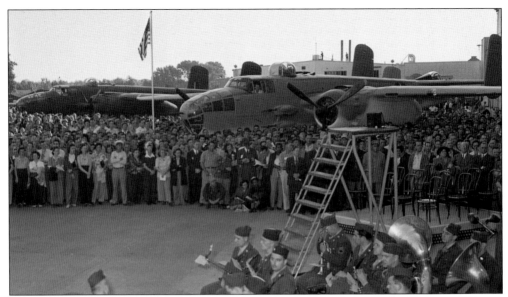

Under the leadership of Harold R. Raynor, the incredible employees at North American of Kansas were able to boost B-25 production rates to a dizzying 300 (or so) per month. Manufacturing improvements enabled variability to be built in on the assembly line, so the modification center was closed, and the space was reallocated to production. The "E" for excellence banner is unfurled before it was hoisted up a flagpole. The Army-Navy "E" award was presented to the best-performing defense contractors. Less than five percent of eligible plants received it. The program was retired when the war ended. The event also celebrated delivery of the 30,000th North American wartime-fabricated aircraft.

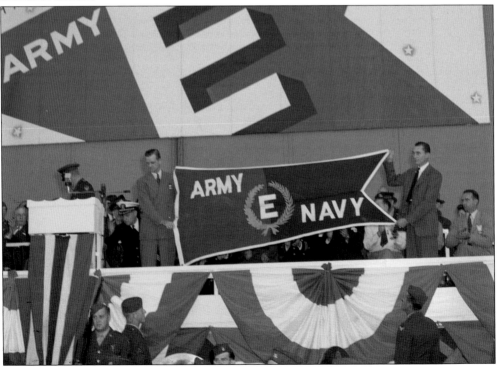

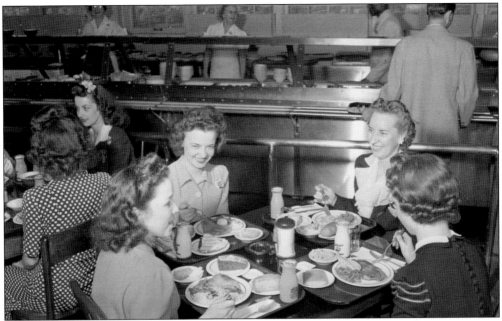

The food service contract was awarded to Harding Brothers and Williams Restaurant Company. Food carts served shop areas, while office workers dined in the new cafeteria. The biggest restaurant in the state of Kansas during war years was documented to be the cafeteria at the Wichita Boeing plant. Fairfax must have been a close second. From left to right, Theresa Martin, Alta Sharp, Edna Cooper, Maude Wood, and Kathy Cindrich are peeling boiled potatoes for potato salad. A machine that could peel 50 pounds of spuds in three minutes was used for raw potatoes.

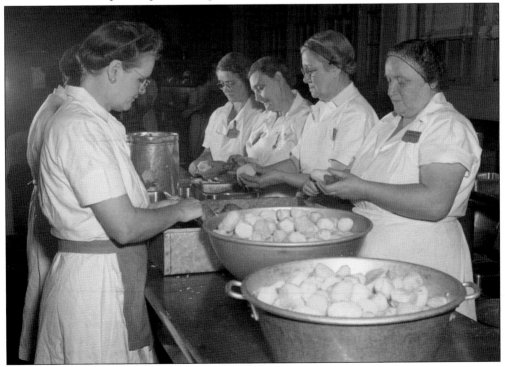

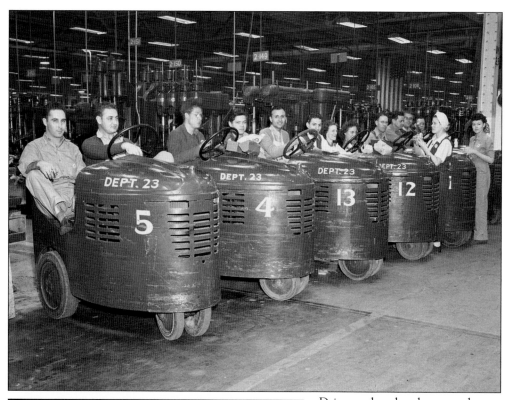

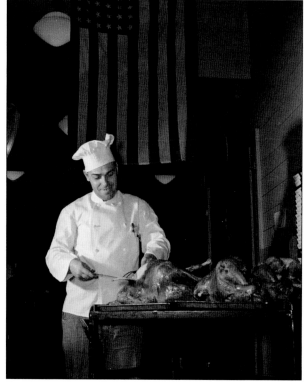

Drivers take a break to partake of their holiday meal as cafeteria executive chef Charles McRoberts prepares a turkey for carving. Thanksgiving 1944 was a scheduled workday and 2,000 pounds of the poultry was prepared for the noon meal. The tugs were built by Clarkat and were called "jeeps." They could pull a train of up to five open-top wheeled dollies, called "cars." The drivers were trained in first aid and ran scheduled intraplant routes to deliver parts and smaller subassemblies to where they were needed. The empty cars would then be picked up and returned to the loading docks for refilling.

Christmas in the workplace was observed by decorating a symbolic tree. Personnel in Department No. 60 were unaware that it would be their last yuletide gathering as they partook of their holiday lunch. Thermos bottles were brought from home, and modest gifts were exchanged, but Santa Claus did not make an appearance. Increased production meant that operations at the plant had smoothed out, which allowed Dutch Kindelberger to give notice on the front page of the *North Ameri-Kansan* that the plant was to be shutdown in observance of Christmas Day 1944; however, management was not happy when the absentee rate jumped to 14 percent on the workday following the holiday.

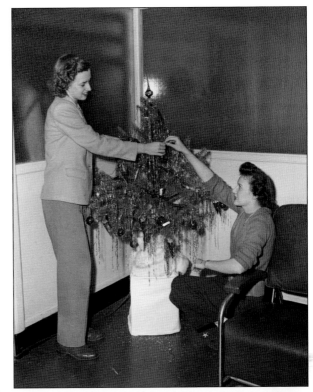

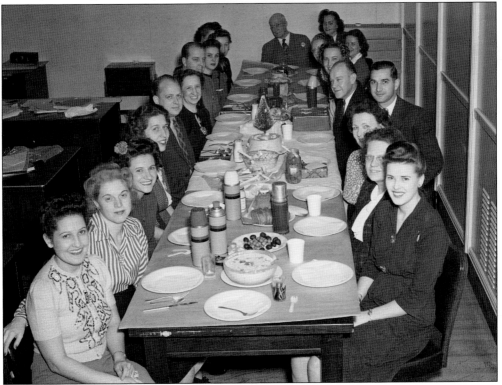

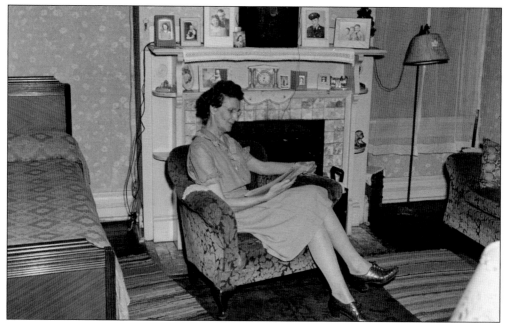

Ida Campbell, one of many older Americans who stepped forward to do their part, rests in her easy chair. She lived in a small but comfortable apartment, surrounded by treasures, which included a photograph of a man in uniform, a radio, lamp, and other mementos. Fireplaces were frequently blocked off because they do not provide much heat during cold spells on the Great Plains prairie.

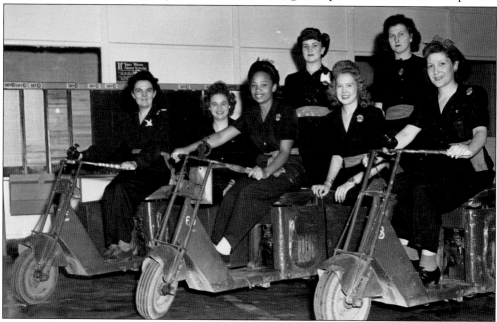

Workers prepare to set off on their motorized scooters. Their department was recognized for achieving a monthly attendance rate of 99.2 percent. Motorized transportation aided productivity by moving people and supplies quickly about the sprawling assembly bays. The workplace was to be kept neat so transportation aisles would remain clear. A disadvantage was the exhaust fumes the scooters spewed.

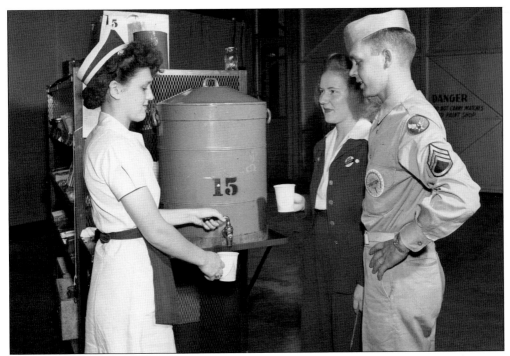

Plant employee Mrs. Howard Winn brings her youthful-looking staff sergeant husband to visit her workplace on July 23, 1942. Visitors in uniform were always welcome and celebrated. As they prepare to share some coffee from a portable food cart, a series of images is recorded for possible publication in the plant weekly newspaper, the *North Ameri-Kansan*, or press releases.

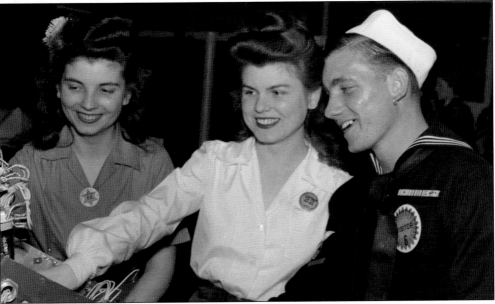

Agnes and Marie Weber are seen with their Navy brother. Agnes was an assistant forewoman while Marie was a leadwoman. Their brother served on a battleship for 21 months before earning leave. He stated that the earring was a treasured gift from South Sea natives. Another brother was at sea aboard an aircraft carrier.

In accordance with the long tradition of airplane factories, North American Aviation, Inc., of Kansas opened its doors for the first time to family and friends of employees on Saturday and Sunday, May 13–14, 1944. Each employee received five admission tickets. A greeter distributes brochures to visitors as they make their way through the entry gates. Multiple temporary wooden ramps were constructed so guests could peer into the interior of the B-25 Mitchells on static display. The turnout was large, as young and old were observed to be in attendance. A few visitors developed sore feet from all the walking.

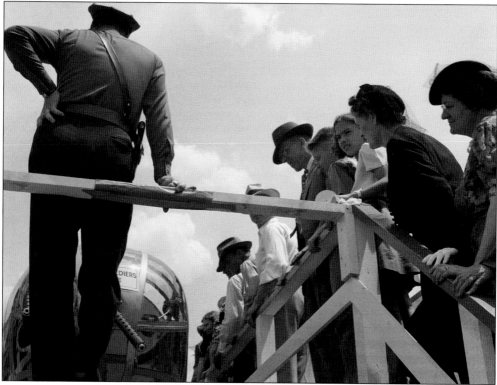

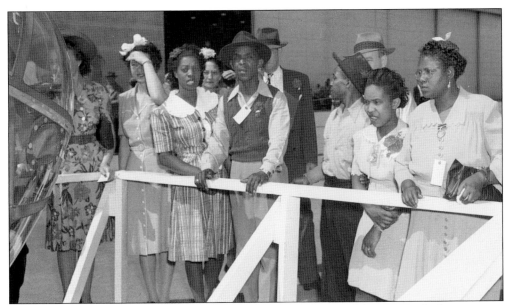

Many visitors wore their best attire to view the displays. Some of them arrived after morning church services on Sunday. A Russian (center man in uniform), clad in his military uniform, joins the others who are viewing the remains of a captured German Messerschmitt-109. The hulk was shipped in for display from the 8th Army Service Command in Dallas. Other captured enemy aircraft were reverse engineered, meaning they were taken apart in search of new technology or other secrets, during and after the war.

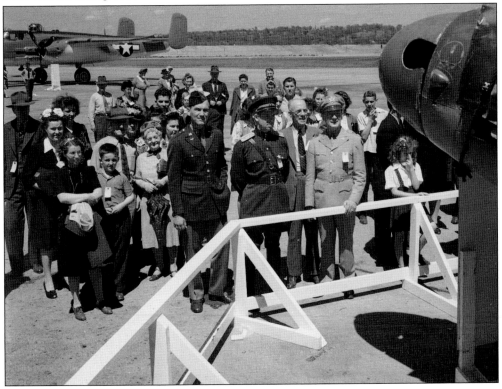

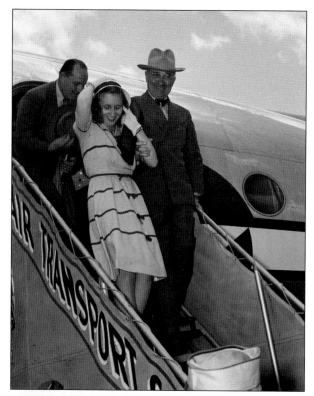

Harry S. Truman landed at the Fairfax Airport on June 27, 1945, aboard the presidential airplane named *Sacred Cow*. He is seen descending the air stair with his daughter, Margaret. She, Truman's brother Vivian, and Mayor Roger Sermon drove to Fairfax from Independence, Missouri, to meet him. Truman climbed into an open-top automobile as the motorcade departed Fairfax and successfully made its way to various events in his honor. Margaret writes in a 1955 memoir that the adoring crowds along the way were "overwhelming."

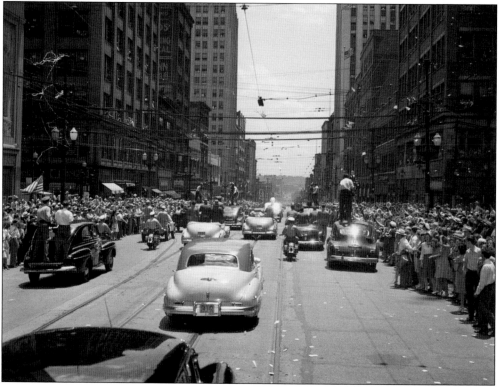

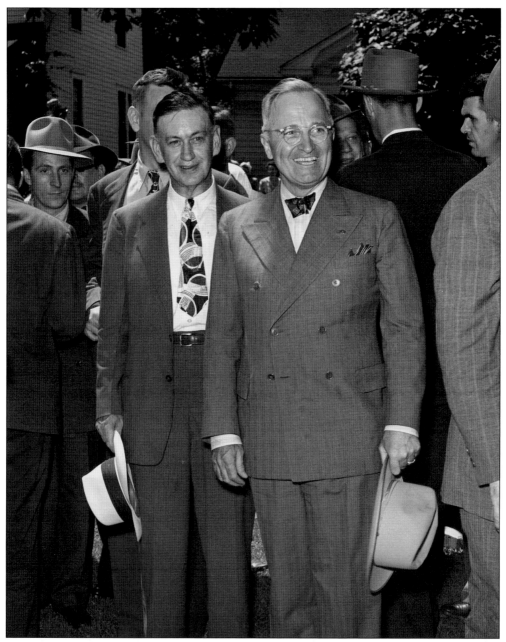

Truman's ear-to-ear smile seems to radiate genuine happiness now that he is back in the Midwest to be with longtime friends, such as Roger Sermon, the mayor of Independence. Pres. Harry S. Truman would soon be making monumental decisions in the quest for unconditional surrender by the Japanese government. He was an accidental president because of political horse-trading at the 1944 Democratic Party convention. Truman ran in 1948 and beat Thomas Dewey, thus becoming president in his own right.

The Air Force Museum estimates that a B-25 cost $109,670 in 1943. If communities or groups donated that amount of money, they would receive a photograph of a B-25 adorned with the name of their choosing. As the war progressed, the names were no longer painted on an airplane. The ruse was carried out in the darkroom when calligraphy was overlaid upon a generic negative and an 8-by-10-inch photograph was created. When individuals seek out the combat history of "their" aircraft, they are disappointed when informed no such aircraft ever existed.

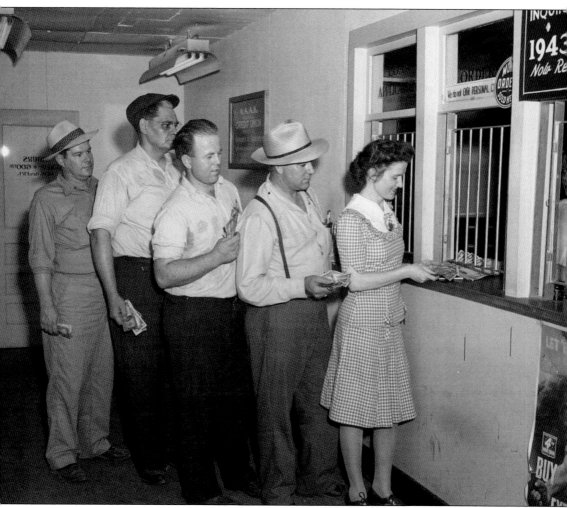

Employees, with cash visibly in hand, line up to purchase war bonds. These bonds were created for a dual purpose. The primary and stated goal was to help fund the war effort by lending Uncle Sam excess cash. The secondary goal was to absorb extra money to stem inflation. No new automobiles could be purchased during the war, and other items were either rationed or in short supply. Too much cash chasing too few goods would have yielded more inflation than was desirable.

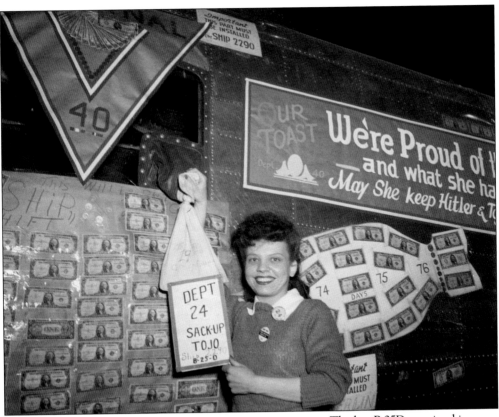

The last B-25D remained in the factory for a time, and it became the "Money Ship." Employees were encouraged to tape donated dollar bills or coins to it. Mechanics removed the currency before it was placed in a safe for the night. When counted, it was determined that almost $10,000 had been collected. All of the funds were donated to the Army and Navy Relief Funds.

One of the more bizarre charity drives yielded free cigarettes for troops overseas. The sponsoring tobacco companies made arrangements to sell the customer 10 packs of cigarettes for $1.60, while eight packs were shipped abroad. If the customer paid $1.60 and took no cigarettes, 31 packs were exported. At that time, the public was unaware of the health hazards of long-term tobacco use.

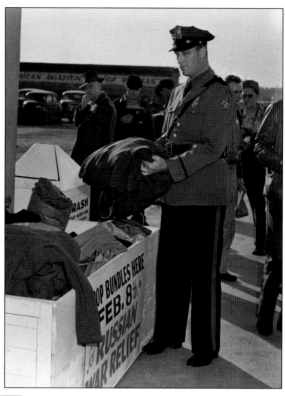

The generosity of the North American workforce was called upon repeatedly. In this case, it was to donate much-needed used clothing for use by Russians, and, here, a plant policeman responds to the request. Russians were frequent visitors to Fairfax at the same time their country was under vicious assault by the Nazis. Most Americans are unaware of the large amount of wartime assistance that was provided to the Soviets by the United States. Nearly 10,000 aircraft passed through Ladd Field at Fairbanks, Alaska, on their way to the Soviet Union.

Share your clothing!

RUSSIAN WAR RELIEF inc.
BRING BUNDLES
Thursday, Feb. 8. only.
DEPOSIT OUTSIDE ENTRANCE DOORS

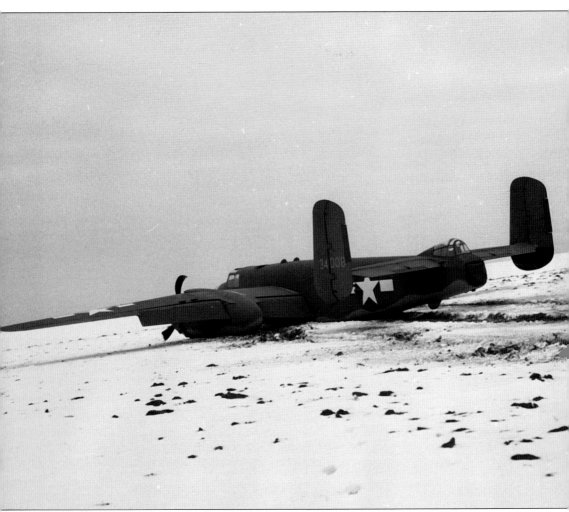

Aircraft accidents were too frequent during the war. Fortunately, many were nonfatal, resulting in damage that could be repaired. Minor wrecks, like this, were kept secret. Fatal accidents were announced. The 13th airplane off the Kansas assembly line encountered serious flight control problems, resulting in a crash on April 26, 1942. The tragedy took the lives of five plant employees who were aboard the test hop. The cause for the in-flight loss of two early airframes was thought to be manufacturing defects, which were a consequence of an inexperienced workforce.

Six

ACCIDENTS AND INCIDENTS

An early version of the Mitchell, the B-25B, had a top speed of 328 miles per hour. As the war progressed, armor plating added weight as additional guns increased drag. Top speed fell to 272 miles per hour in later models. In addition, a new ground-attack airplane from Douglas, designated the A-26 Invader, was seriously behind schedule. Therefore, a single experimental B-25, called NA98X, was assembled at Inglewood to demonstrate a lower-cost alternative. The "NA" stood for North American; "98" was a production contract number; and "X" was for experimental. It was not given a military designation because it was a company-sponsored initiative.

NA98X featured more powerful engines, bigger ailerons, a low-drag turret, and other improvements. The twin Wright R-2800 engines produced a hefty 2,000 horsepower each. It was the only B-25 airframe ever mated to R-2800 engines. The maiden flight was on March 31, 1944. Company test pilots took it up 16 times. It performed like a fighter, so it was agreed to limit its top speed to 340 miles per hour and restrict sharp turns.

The aircraft was turned over to the Army when a contingent of officers from Wright Field arrived in Los Angeles on Friday, April 21, 1944. At sundown on Monday, April 24, NA98X came to rest as crumpled metal with parts and pieces strewn about the plant's flight line and adjacent airfield. The official accident report said both outer wings broke as the heavily laden aircraft was put into an abrupt climb from a low-level pass at an estimated 380 miles per hour. The result was not only fatal to the two-person flight crew but also the project. All work on the promising B-25 variant was immediately stopped and never restarted.

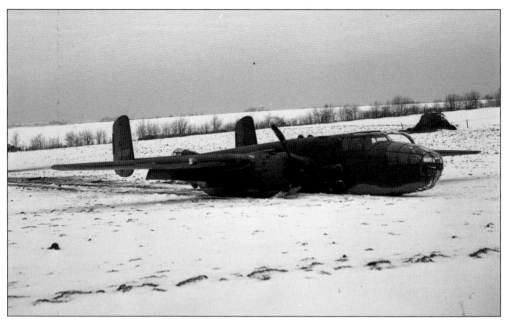

Snow on the ground may have contributed to the accident, but it also allowed the airframe to slide to a gradual stop, making injuries less likely. Separately and on the ramp, a flight line mechanic named Winans lost his life when he walked into a spinning propeller on February 23, 1943. The only other casualty was a 20-year-old female plant worker, Irene Freestone, who died in an explosion when a lightbulb was thrust into a fuel tank rife with volatile sealant vapors.

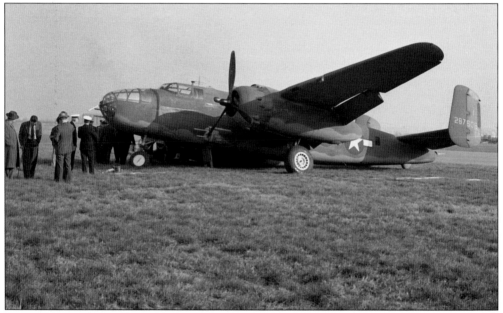

One main gear has collapsed leaving the opposite wing high in the air. Sometimes there are discrepancies reconciling the number of airplanes built with the number of delivered. Predelivery wrecks can account for some of the variances. World War II accidents were investigated, and reports were prepared; however, they were quick and shallow as compared to modern-day aviation accident investigations.

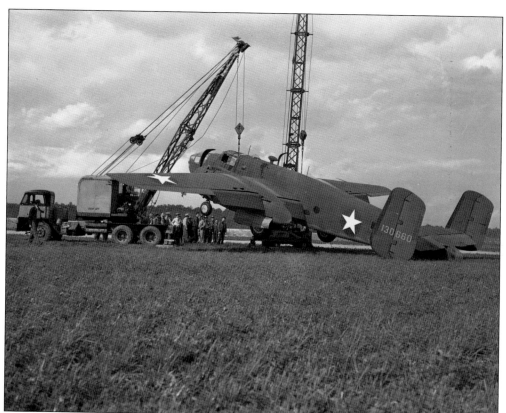

Two cranes work in unison to retrieve this damaged B-25. Production records are further clouded because spare part production was sometimes translated into complete airplane equivalents. Some wrecks could be repaired, while other airframes were written off. Parts still serviceable could either be reused on the assembly line or offered as spares.

This isolated incident demonstrates there was at least a modicum of racial disharmony at the Kansas City plant. Other outlaw acts, such as spray-painting swastikas on cafeteria trays or a piece of cow's lip in the lunchtime cafeteria chili, were photographed and investigated. With the wartime demand for labor, some bad people made their way onto the payroll.

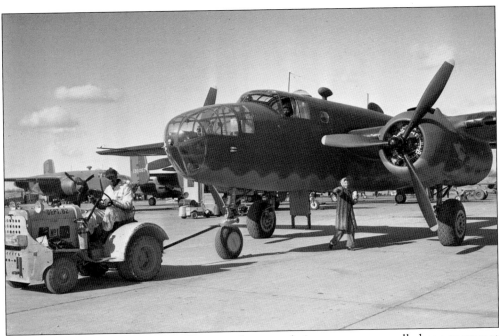

Safe towing is vital to moving airplanes on the ground. A tow team normally has a spotter at the tail and a guide at each wingtip. Pictured below, bystanders gawk at a towing operation gone awry, which yielded broken Plexiglas and a crushed bombardier's compartment. The root cause was not recorded, but may have been placing the nose gear down but not locking it; pushing too hard when the brakes were applied; or backing into an obstruction. Army censors determined this and other photographs of accidents or incidents to be classified. Images unflattering to the war effort were kept under wraps. Very few of them have found their way into public view.

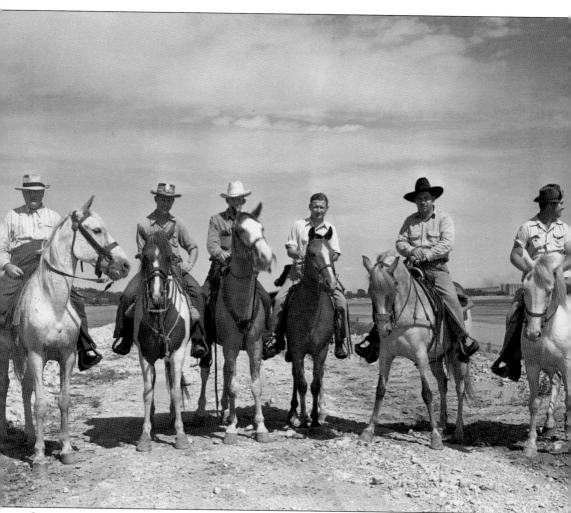

Contrary to appearances, this is not the Dodge City contingent reporting for work. These men are civilian volunteers who patrolled the dike on the north side of the plant when the Kaw River was at flood stage. They demonstrate the type of attire and equestrian skills handed down from their parents and grandparents, the exceptional people who first tamed and then settled the wild American West. Monitoring the dikes during times of high water had little to do with the newly arrived airplane factory. It was a tradition done in their own best interests because the dikes protected their buildings, pastures, and livestock from flooding.

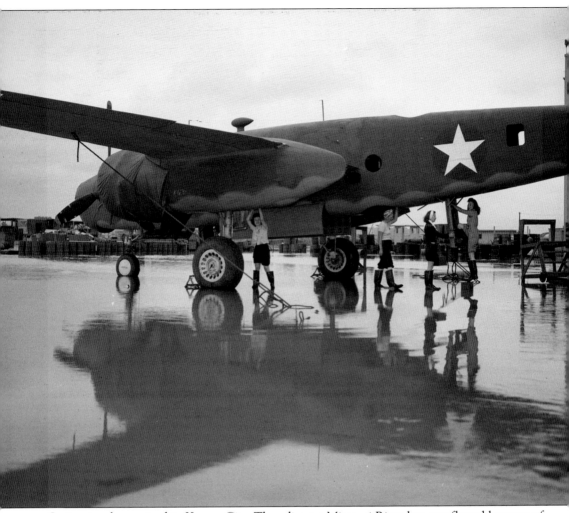

Springtime has arrived in Kansas City. The adjacent Missouri River has overflowed because of upstream snowmelt. The lightly dressed mechanics, in this case all women, have donned rubber boots and continue with their normal duties in spite of floodwaters overflowing the concrete-paved ramp. The visibly missing turrets and windows show that this airplane is incomplete. The downward-hinged aft crew entry door is open. Another crew entry door is located forward of the wing. Completed aircraft were assigned to one of a number of crew chiefs. Each crew chief was responsible for three planes and had three to five mechanics on his team.

Seven

US Army Air Corps
Ferry Command

Increased aircraft production fueled the demand for more crew members to fly them. Additional training bases were constructed in the warmer parts of the country so that flying could be conducted in all seasons. In addition, contracts were established with civilian companies to train pilots. Bombardiers, navigators, radio operators, and gunners were also needed. The traditional yearlong curriculum for pilots was shortened. Brig. Gen. George Stratemeyer was responsible for aircrew training. In a 1942 article, he boasts the following: "At the end of ten weeks he (a cadet pilot) should be proficient in all fundamental maneuvers in a primary trainer. A recent class of 146 members flew an aggregate of 3.8 million miles without a fatality . . . No other country in the world can spare aviation gasoline for anywhere near that much cadet flying; but we feel that it is essential for good pilotage and we have the gasoline."

Some freshly trained aviators found their way into ferry command. They maintained a constant presence at Fairfax, but their departure routes and destinations were not discussed or even speculated about. Consolidated Aircraft of San Diego won a contract in early 1942 to ferry Inglewood-built B-25Bs from San Francisco to Brisbane, Australia, with fueling stops at Hawaii and other Pacific islands; however, the reality was that many B-25s were flown to port cities where they were loaded aboard ships for dispatch across the oceans to their next destination.

The Kansas City plant was unique for North American because the land, buildings, and all equipment were government-owned. North American Aviation, Inc., functioned solely in the capacity of an agent. It owned nothing but manufacturing and patent rights, yet managed the operation as though the plant were its own. This put a large responsibility on the recently promoted government representative, Lt. Col. Leo G. Schlegel. Schlegel was the commander of four other officers and assigned enlisted members, as well as responsible for a much-larger staff of civil servants who also reported to him. They performed quality-assurance inspections, accepted airplanes when they met specifications, and presided over all financial transactions.

Halloween 1942 was celebrated with a dance at the USO (United Service Organizations) Headquarters at 3200 Main Street. To the delight of others, Eldon Banky, a soldier, succeeded at bobbing for apples and won the contest plus the associated $1 prize. An enlistment contract during World War II stipulated a service commitment of "duration of the war plus six months."

The Women's Auxiliary Ferrying Squadron (WAFS) and the Women's Flying Training Detachment were merged on August 5, 1943, to form the Women Airforce Service Pilots. WASP was a quasimilitary organization, which utilized women who were already licensed pilots to ferry airplanes about the country. They were civilians but wore a military-like uniform. A detachment of WASPs arrived for assignment at Fairfax in April 1944 and was boarded at the Hotel Boulevard Manor in Kansas City, Missouri. On B-25 flights, a WASP would frequently be teamed with a male ferry command pilot. A number of marriages between WASPs and military aviators were recorded.

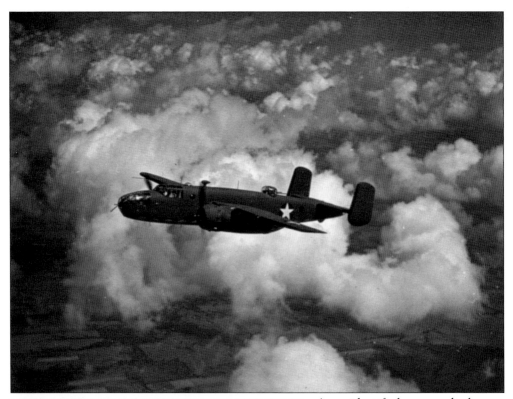

An unidentified woman climbs into a B-25. A July 2, 1943, news item reports: "A footnote was added to aviation history last week at the Fairfax Airport when Nancy Harkness Love of Boston, senior squadron leader of the Women's Auxiliary Ferrying Squadron, flew a B-25 Mitchell in from the West Coast. Mrs. Love became the first woman in American military history to pilot a bomber on a cross country trip." The number of WASP pilots peaked at 1,074, with the goal to release a like number of men for combat duty overseas.

A Lieutenant Funkhouser is photographed with his ferry command crew on December 7, 1942. The American war machine was gearing up quickly on the first anniversary of the Pearl Harbor attack. Military flight crew members wear wings on their chests. The design in the center of the wings varies by crew position. There are separate designs for pilots, navigators, and enlisted crew members. These men fly in dress uniforms. In later years, one-piece coveralls and soft-cloth flight caps became the normal attire for Air Force flight crews. The coveralls are more likely to stay on the aviator should bail out become necessary.

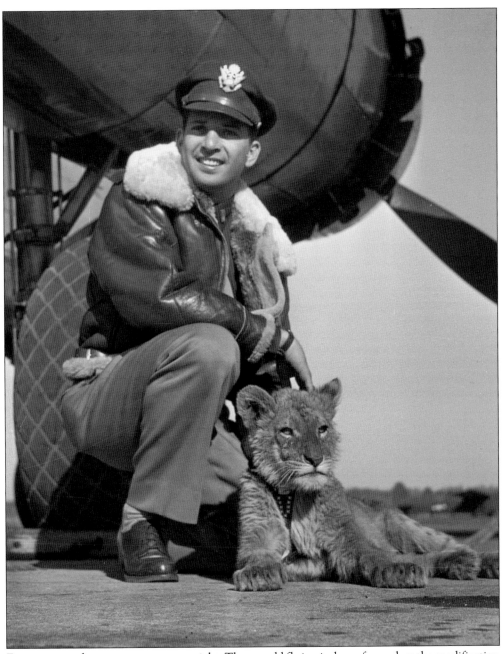

Ferry command crews were a constant sight. They would fly in airplanes for work at the modification center and fly out aircraft to their next destination. This ferry command crew member travels with a lion cub in the tradition of Roscoe Turner, a dashing 1930s aviator. A ferry crew might be three people—a pilot, copilot, and navigator. A combat crew was most often made up of five men—a pilot, copilot/turret gunner, bombardier/nose gunner, radio operator/waist gunner, and tail gunner. Women were banned from combat.

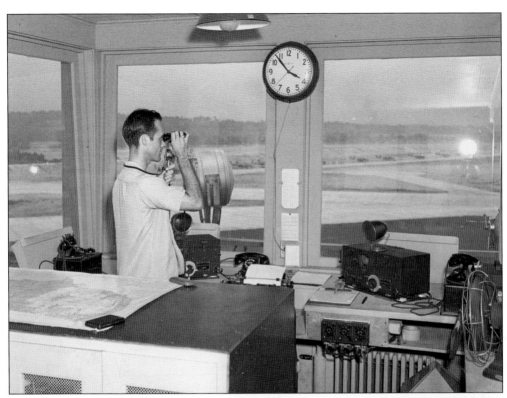

The control tower radio operator supervised airfield arrivals and departures at Fairfax Airport. There were plenty of flight operations to keep him busy. Army captain W.H. "Pokey" Pochyla (left), an Air Corps pilot stationed at Fairfax, and crew chief (mechanic) Toni Larson prepare to take this B-25 on a test flight. A single pilot could easily fly the Mitchell bomber. The crew chief personally guaranteed the plane was airworthy by participating in all test hops. The merit of wearing a parachute was demonstrated on July 18, 1942, when line No. 87 became uncontrollable, and the three crew members aboard each jumped to safety. One of them suffered a leg injury upon landing.

Maj. Peter Ryatzontzev (left) and a Major Sebulov hold a copy of a B-25 flight manual printed in the Russian language. Plant employees remembered the Russians as battle-hardened and experienced pilots. This B-25 wears the red star of the Soviet military. They departed Kansas City heavily loaded with spare parts and other urgent war supplies. Sometimes Russians flew them, and sometimes ferry command took them. The usual route was Great Falls, Montana, to Ladd Field, near Fairbanks, Alaska. Calgary, Alberta, Canada, and White Horse in the Yukon Territory were available if intermediate fueling was needed. B-25 flights from Ladd into Siberia and beyond were conducted by the Soviets. Over 7,900 military airplanes transited Ladd on their way to the Soviet Union.

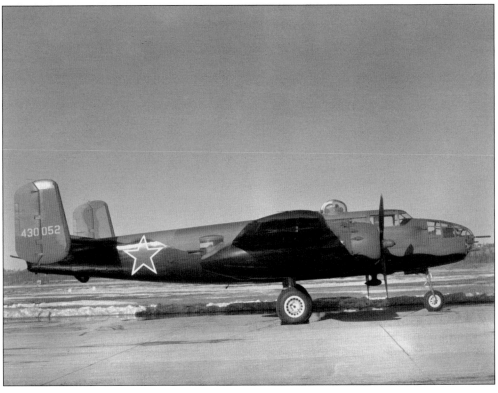

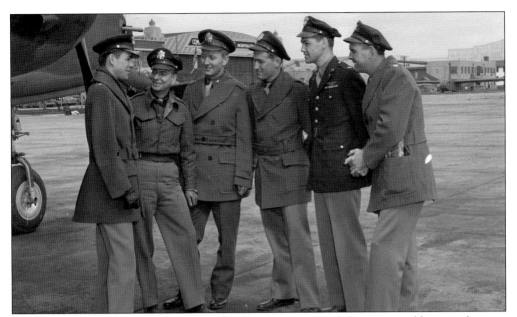

American aircrews were given a quota of wartime missions and then returned home to become trainers. These combat veterans are visiting Fairfax. In contrast, because replacements were not forthcoming, enemy military aviators assigned to combat were expected to fly into harm's way, most frequently, until they were dead.

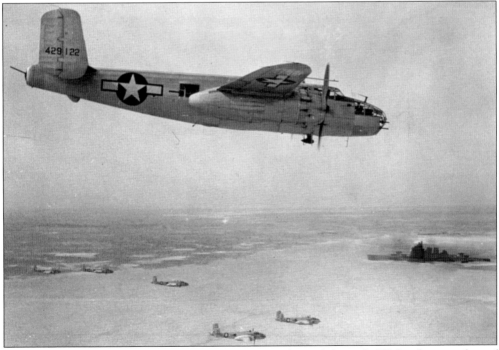

Aircrews in training line up their B-25s for a mass attack on a life-sized, 650-foot-long mockup of a Japanese Takao-class cruiser, dubbed the "Muroc Maru." The "Maru" was constructed in 1943 in the high desert at the south end of California's Rogers Dry Lakebed and replaced a training facility located in Hawaii.

Muroc Maru was fabricated of four-by-four timbers and chicken wire and covered with feathers. Visitors to the area thought they were seeing a mirage. The Maru was frequently shot up but it never sank—until it was removed as a hazard to flight in 1950. The dismantling was complicated by a large amount of unexploded ordnance in the soil surrounding it. Muroc Army Airfield was later renamed Edwards Air Force Base in honor of Glenn Edwards, a test pilot killed in the crash of a Northrop Flying Wing in 1948. Edwards Air Force Base remains the Air Force's primary flight-test location because of its remote location, good flying weather, and its large dry lakebed where airplanes can land in case of emergencies.

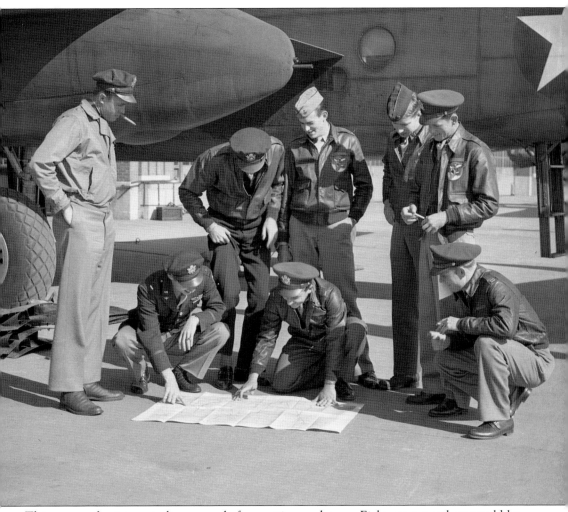

This group of aviators studies a map before getting underway. Eight crew members would be enough to take three airplanes across the country in a multiship formation. All B-25s had a small toilet installed in the aft fuselage. It was not enclosed. The photograph, like many others, was classified for reasons no longer understood.

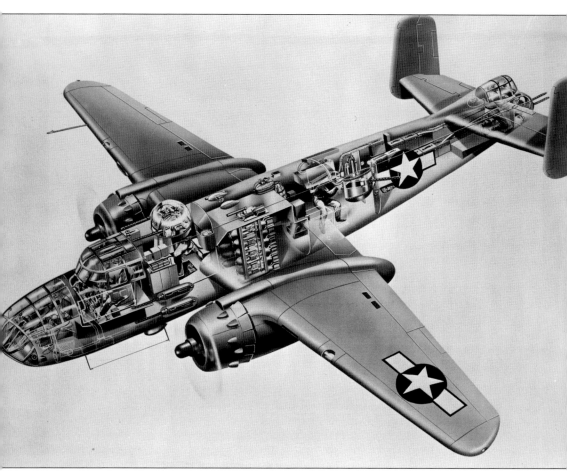

A cutaway drawing shows the configuration for the final model of the B-25 that ferry command would be called upon to fly away from Kansas City. It was designated B-25J, and it was only built at Fairfax. The plant became the world's sole source of B-25s after Mitchell production was halted at Inglewood in mid-1944.

Eight

PRODUCTION HITS STRIDE

The United States, Mexico, and Canada were spared the infrastructure damage inflicted upon Germany, Japan, Russia, and many other countries. Essentials like food and fuel were plentiful. Gasoline was rationed because civilian automobile tires were in short supply. The vast railroad system remained intact to transport the surge of people and everything else necessary for domestic consumption concurrent with sustained military operations on two major overseas war fronts.

It was a struggle to get production problems at NAA-K resolved. North American described what evolved as the "component breakdown" method of production. The key was a steady, uninterrupted forward march of a moving assembly line. It required orderly thinking and advanced planning. It demanded that each job be done in its proper place and time with a minimum of confusion. The movement of the assembly line set the psychological pace for every production worker in the plant. The concept was used at all North American plants.

A unique feature at Fairfax was an elevated continuous-chain conveyor, which carried B-25 tail assemblies near the ceiling and high above the assembly line. The conveyor brought the tail assembly down to a marriage with the aft fuselage where it was permanently attached. Each piece or component, in turn, was added as the aircraft continued its forward progress toward the factory exit door. Any missing pieces would catch up (or "travel") to be properly installed as the aircraft sat on the flight ramp.

The moving assembly line was lost to the aircraft industry in the decades after the war but was revived in recent years. A notable example is the moving 737 assembly line in the Boeing Company factory located in Renton, Washington. It is building (at the time this writing) about 40 aircraft per month. In contrast, Fairfax sustained a production rate in the range of 300 per month during the last two years of operation. Other wartime plants in other cities, operated by other companies, achieved similar production results.

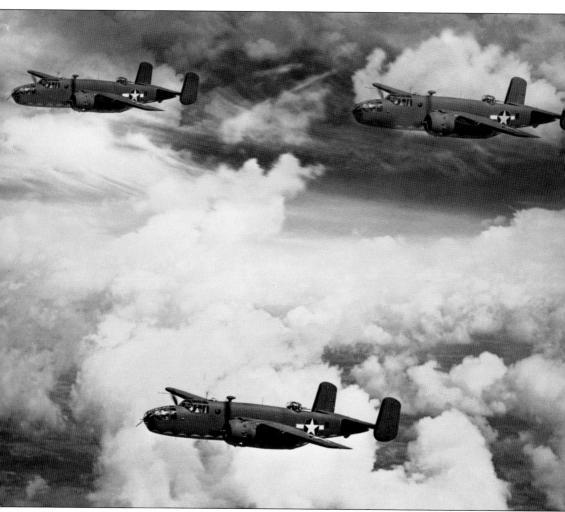

Each B-25 was test-flown at least twice prior to delivery. The maiden flight lasted about an hour and key components were tested for proper operations. On return, any problems or "squawks" were addressed. A much smaller sample was flown 300 miles west of Kansas City to the Cheyenne Bottoms Gunnery and Bombing Range near Great Bend, Kansas, to test-fire the machine guns in flight. In the spirit of competition, pilots were known to open the bomb bays to see who could collect the most wheat when returning. One trophy winner landed back at Fairfax with a fence post and a couple hundred feet of barbed wire.

A graphic, high on the wall for all to see, depicts work accomplished at the modification center. It was a long distance between the main factory and the modification center. People needing a lift between the two sites stood in a shelter on either end. Drivers were expected to pick them up and give them a ride. Carpooling was encouraged during the war because of rationing.

A one-handed painter is seen wielding a paint sprayer to coat an airplane part while a breathing apparatus protects him from paint fumes. Labor Secretary Frances Perkins stated the following during her visit to Fairfax: "It is interesting to me to see how handicapped workers and war veterans are placed in jobs. It shows the capabilities of industry in using these people."

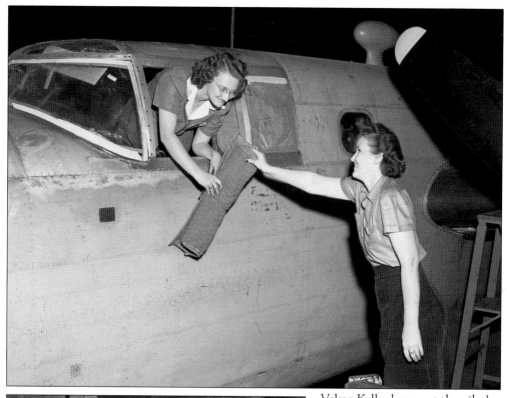

Velma Keller leans out the pilot's compartment to receive a window curtain for a B-25 from Katherine Lyons. The Mitchell was not well insulated and offered a noisy ride mostly because of engine exhaust. Various types of exhaust manifolds were developed. They were then tested for their ability to hide exhaust flame at night and suppress noise.

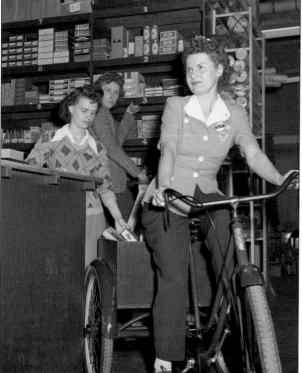

Nonproduction stores stocked plant and office supplies that were not airplane parts. Stationery, mops, lightbulbs, and other consumer items were found here. A bicycle with a basket is a time-tested means of transportation in airplane factories—whose area is measured in acres. Irene Campbell is on the bicycle, while Margie Zakarias is in the background.

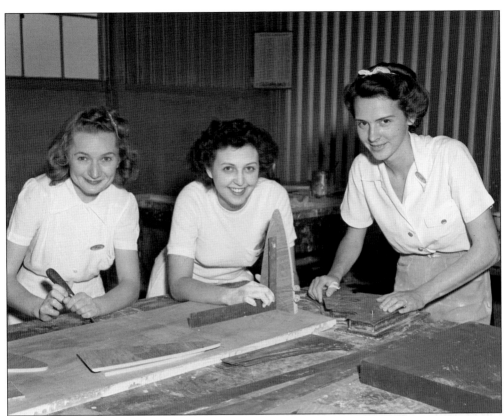

The foundry was a hot, dangerous, and dirty place to work. Molten metal was poured into molds to create forgings. As foundry workers, these three women seem to be very clean and brightly dressed. They are, from left to right, Franciene Litton, Dahrl Hailman, and Mary Ann Bransby. The photograph is dated July 29, 1942. The medical dispensary was a cleaner place to work. The dispensary could examine ailing workers, render first aid, or perform flight physicals. Employee assistance programs trace back to the wartime experience when long hours, rationing, and loved ones gone to war put many people under stress.

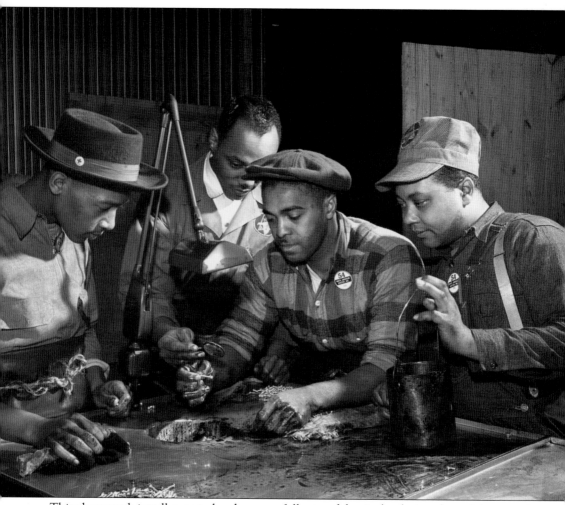

This photograph is well executed and was carefully staged, but it also depicts the racial segregation that was considered normal at that time. The African American workforce at North American of Kansas never exceeded 10 percent, and a disproportionate number of them were assigned to Department No. 47—service and janitors. The system, in place at the time, made it unfairly difficult for nonwhites to move into more highly skilled and better-compensated positions.

America was segregated for the first half of the 20th century, and that segregation is evident in this and other images. This is the African American basketball team. The experience of World War II accelerated the shift toward integration of the races. President Truman signed Executive Order 9981, which directed the end of military segregation on July 26, 1948.

Plant supervisors pose for a group photograph. The Kansas plant was considered to be a good place to work. It was established in haste, and it was abandoned even more quickly. Personal bonds were formed, and surviving employees would get together for periodic reunions in the decades that followed. A commemorative plaque was dedicated in 1998.

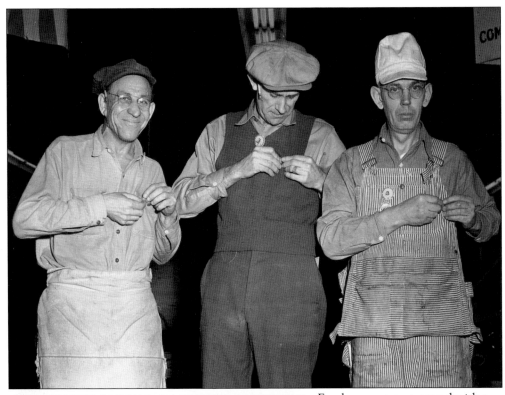

Employees were presented with a pin in recognition of one year of service. Many Americans had only recently suffered unemployment and underemployment during the Great Depression of the 1930s. Women of all ages, minorities, and older men—since the pool of younger men had been conscripted into military service—shouldered much of the war-mandated work in America. People with handicaps were welcomed into the workforce, and little people were especially sought out. Their short stature made it possible for them to do important tasks in spaces too small for most others.

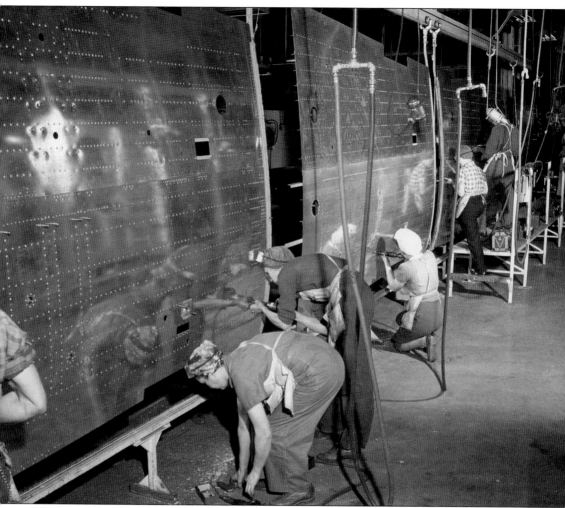

The Kansas City plant was intended for final assembly. It would rely on the arrival of subassemblies from vendors like Fisher Body, a component of General Motors located in Memphis, Tennessee. However, part-fit problems were encountered, and these hobbled early production. Production rates improved when the mix of parts fabricated in-plant was increased. The photograph depicts wing skin assembly.

Airplanes are smooth and sleek on the outside, but there is a tangle of tubing and wires on the inside. By World War II, the number of redundant systems being designed into airplanes was increasing. This meant many in-flight failures could be survived; however, an engine failure on take-off can doom a heavily loaded B-25. Females made up 40 percent of the Kansas workforce.

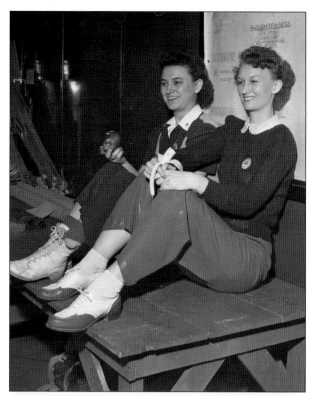

At right, the Robinson sisters enjoy fresh fruit while they take a break. Certain foods were rationed during the war. For instance, the metal shortage restricted canning, which created a temporary coffee shortage. A higher percentage of Americans lived on small farms, which enabled them to could grow much of their own food. Below, the Gable sisters chat as they eat their brown bag lunches. Lucille (right) was a member of the first group of women who went to work on January 19, 1942. She was also the captain of the Bomberetts, a female bowling team. Her sisters were hired soon after. Ruth (center) was a small-machine-parts assembler, while Dorothy riveted.

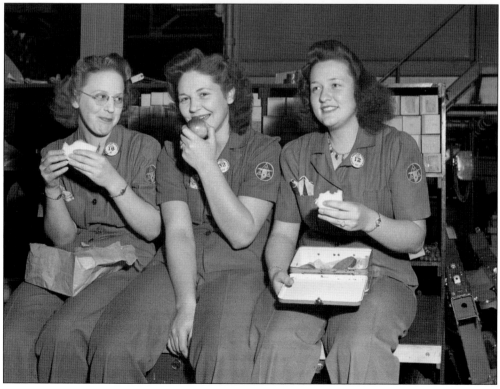

MUST WORK OR GO TO WAR.

Excessive Absenteeism Means Reclassification in Kansas.

TOPEKA, Dec. 28.(AP)—Men deferred from military duty for essential war work must show good attendance records or face reclassification in 1-A, available for induction, state selective service headquarters announced today.

Maj. W. E. Treadway, legal adviser, said employers would report cases of excessive unexcused absence to draft boards, which promptly would reclassify the laggards.

In January 1943, absenteeism averaged 8.2 percent, and production quotas were being missed. Long hours and rationing complicated the personal lives of employees. Several programs were initiated to address the problem. Work schedules were adjusted to five days of 10-hour shifts, and a weekday off was included for handling of personal business. First shift started at 7:00 a.m., while second shift commenced at 5:42 p.m. The Selective Service provided draft deferments to young men with wartime critical production skills. These men were barred from joining the military. By early 1945, absenteeism had fallen to 3.2 percent as a result of the actions taken.

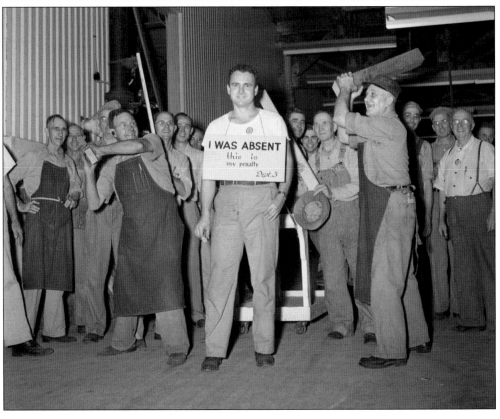

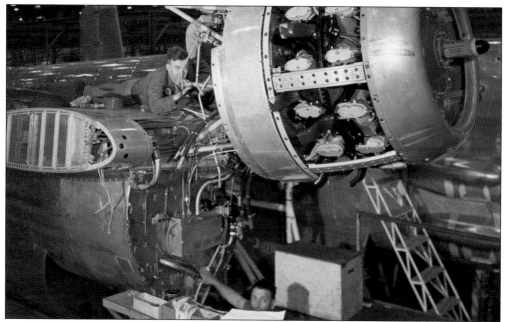

The B-25 was powered by twin Wright R-2600 air-cooled radial engines. Each engine produced 1,700 horsepower and turned a three-bladed Hamilton-Standard propeller with a diameter of 12 feet, 7 inches. This view of attaching the engine to the nacelle conveys the complexity of assembling an aircraft and repeating the process 600 times every month (two engines per airplane times 300 airplanes per month).

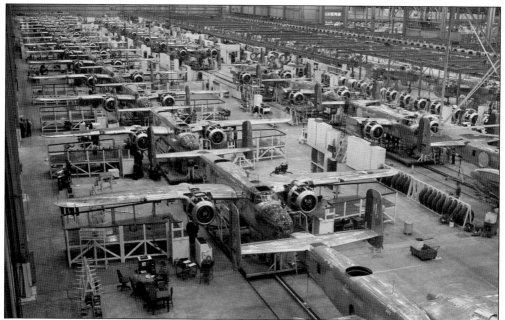

It is difficult to fathom the number of airplanes that moved down the assembly line. All of the key structural parts needed to arrive on time or else the line would come to a stop. Modern factories rely upon computers and robots. Neither technology was available in the 1940s. Manual methods were utilized to organize, control, and manage the work.

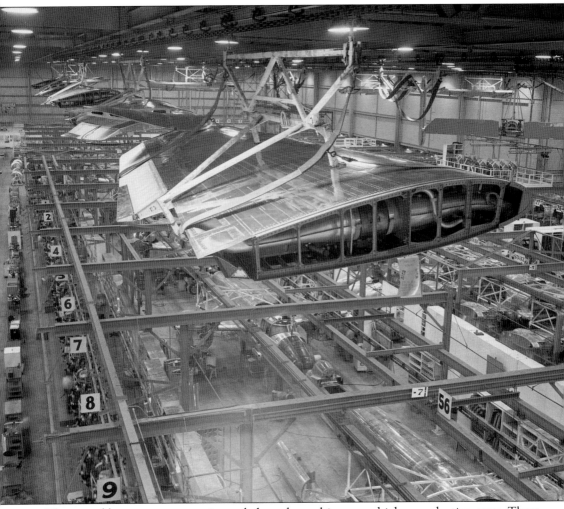

The assembly process was continuously honed to achieve ever-higher production rates. These ceiling-mounted wing conveyors are an example of automation and efficiency that helped earn the Army-Navy "E" award. On the floor, the assembly line was not in continuous motion, but instead, it was periodically "pulsed." This means that the entire lineup of airplanes in final assembly would be moved forward by one position. All tasks at a station were to be complete in time for the line to move.

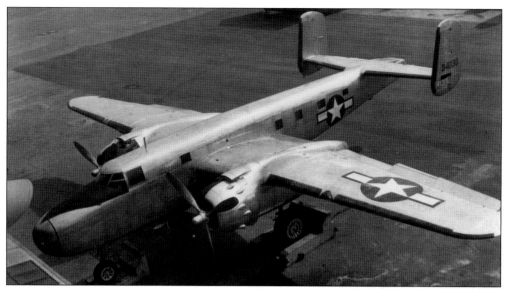

Kansas City–built "J" model serial number 43-4030 was chosen for modification into a transport craft for the wartime use of Gen. Dwight D. Eisenhower. Visible alterations include a custom nose, additional windows in the fuselage, and lack of guns. Structural work was required when the top of the bomb bay was lowered to make a bunk. Eisenhower flew in it frequently until a pair of larger C-54s replaced it in May 1945. The cockpit of this aircraft is typical of all other B-25s. The NAA logo can barely be made out on the rudder pedals. The airplane later served as a government VIP transport stationed at Andrews Air Force Base near Washington, DC, prior to its retirement in 1958. It is preserved and can be seen at South Dakota's Ellsworth Air Force Base Air Museum.

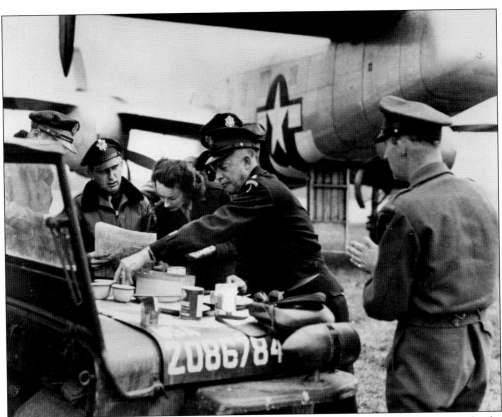

Supreme Allied Commander Gen. Dwight D. Eisenhower (second from right) and a trusted aide, Kay Summersby, partake of a field lunch from the hood of a jeep at an airfield near Mons-en-Chaussée, France. Army Air base A-72 was located midway between Paris and Brussels. Eisenhower is meeting with B-26 pilots, and the exact date was not recorded. Although the serial number on the tail is not visible, the fuselage side windows and sheet metal covering the aft gun mounts make it evident that the airplane is Kansas City–built 43-4030. Research indicates Eisenhower used the B-25 frequently (but not exclusively) during the year after it was delivered. (Courtesy of the Dwight D. Eisenhower Presidential Library & Museum.).

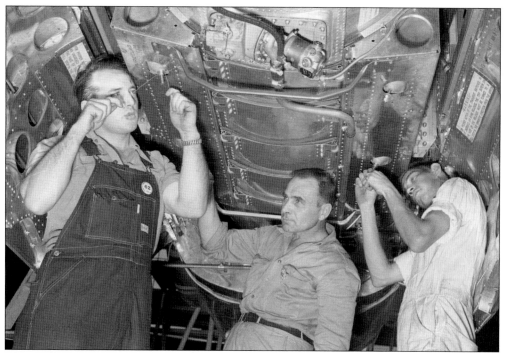

Above, these technicians are working to install an optional fuel tank in the bomb bay. The extra fuel, combined with a leisurely cruise speed of 233 miles per hour, increased the B-25 ferry range. Some auxiliary full tanks could be jettisoned in flight. Below, an industrial photographer is being directed to record the contents of the bomb bay. The photograph is being taken for the North American Department of Field Services. Then, as now, field services representatives worked for the manufacturer and accompanied their aircraft wherever they went. A good representative should demonstrate a mix of excellent mechanical, interpersonal, and communication skills—all while enduring extensive travel.

In February 1945, Lockheed requested the Kansas City plant be readied for production of a new jet fighter, the P-80. Work began on building jigs for the new airplane, and space was vacated for its assembly. In May, after the German surrender, word was received to cancel the project and 1,500 people were immediately terminated from work. All that remains of the aborted P-80 project is a stack of photographs of various jigs and tools that were in development. This happens to be a milling fixture, pictured below. Jigs and tools are vital to aircraft building. They allow relatively unskilled people to perform tasks that would otherwise be too demanding. Work simplification is the key to reliable mass production.

Nine

SHUTDOWN AND CLEARING THE FACTORY

The success story of North American Aviation, Inc., of Kansas was the accomplishment and dedication of the people. Few had manufacturing experience, and still fewer had ever worked around aircraft. They arrived with a work ethic, came together, received training, coalesced as a team, and successfully built the high-quality warplanes that played a key role in the stunning World War II Allied victory. The story of their accomplishment deserves to be better understood, remembered, and appreciated.

The *North Ameri-Kansan* documented various initiatives to bring other aircraft production to Fairfax. The first was the B-29 expansion of early 1942, which was dead by mid-1942. Lockheed provided a sample P-80 jet fighter to Fairfax in February 1945. A project was launched to make production preparations. Tooling was in development while space for the assembly line was being cleared. The project was aborted just three months later. Kindelberger hinted at the need for transports, and some work on an airplane known as the Fairchild C-82 was performed at Dallas. In 1945, Kindelberger also made reference to classified projects that were in gestation. None of the opportunities came to fruition for the Fairfax employees. Over 6,000 B-25 Mitchells were the legacy of North American Aviation's only foray into Kansas.

In four short years, it was over. America was awash in warplanes. B-25 production was abruptly halted on August 17, 1945, when it became evident that the capitulation of the Japanese was imminent. The majority of the already scaled-back local workforce was sent home, while a rapidly shrinking pool of workers was retained to wind up operations by making the airplanes in final assembly flyable, cleaning out the factory, and boxing up vital records for long-term storage in California. One-by-one, the small cadre of Inglewood people drifted back home.

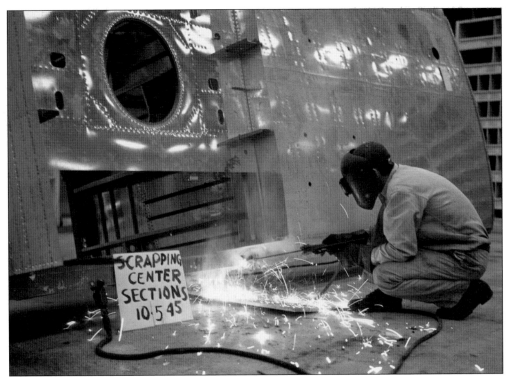

Brand-new center sections are being cut up for recycling on October 5, 1945. Scrap steel from tooling and aircraft-grade aluminum was then loaded into railroad gondola cars for shipment. Plant machinery was quickly sold off to middlemen dealers of used industrial equipment. The massive government-owned factory was soon vacant. The decision to halt production was not anticipated. All upstream suppliers were simultaneously directed to immediately cease production.

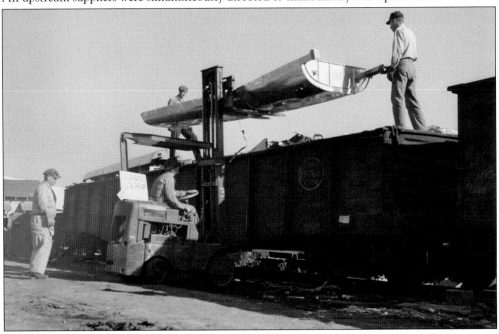

On October 15, 1945, plant manager Harold Raynor is one of the very few employees still on the job, as he takes time to pose with the last B-25J. Two months after the decision to shut down B-25 production, the last of 72 "incomplete but flyable" aircraft was readied for departure. This B-25J model was incomplete because it was shorn of the armaments stipulated in the contract.

A transport version of a B-25 is still in US Air Force service when photographed in 1959. Transport versions were designated as CB-25s. The "C" designates "cargo," but without a large cargo door, the CB-25 was better suited as VIP transport. The B-25 was a better postwar transport than the competing Martin B-26 Marauder because of its larger fuselage and more docile in-flight handling characteristics.

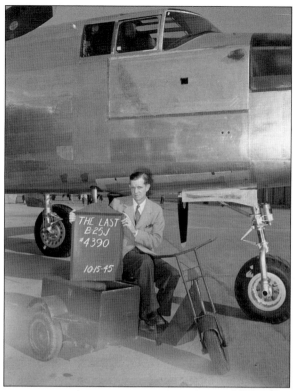

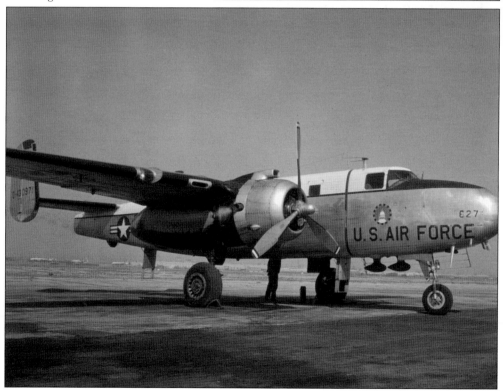

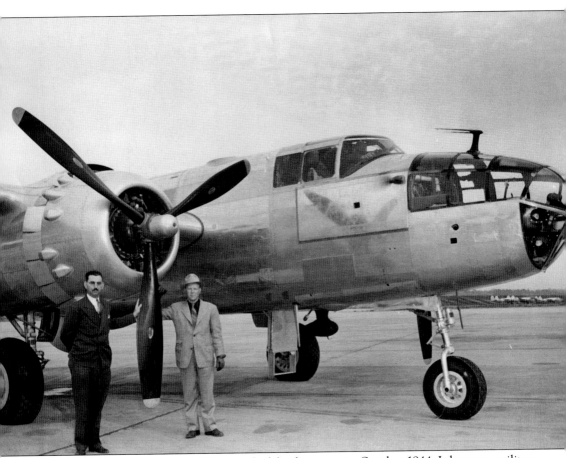

One of the last war surplus B-25Js is readied for departure in October 1944. It bears no military markings, and nobody in uniform is present. The US military was in the process of being demobilized at the time. The surplus airplanes in the huge inventory were exported to other nations, released to other government agencies, cut up for scrap, or sold for civilian uses, which included transport, pilot training, firefighting, air-to-air photography, and even some drug-running in South America. Surplus B-25s were abundant and cheap in the decade following the war. Meanwhile, a month later, in November 1945, the official North American Aviation, Inc., of Kansas workforce headcount would number zero.

General Motors badly wanted the Fairfax plant and made a written offer to the government in 1945 to pay $500,000 annual rental plus the creation of jobs for an estimated 4,000 to 5,000 people. The offer was accepted, and GM took occupancy of the recently vacated plant on December 1, 1945. The first automobile rolled out in June 1946. The postwar demand for cars was high because the public could not purchase them during the time of hostilities, when automobile factories had been retooled for military production. As stipulated in its offer, GM shared part of the plant during the Korean War so F-84 Thunderstreak jets could be built there. The former B-25 factory was abandoned in 1987 and later dismantled. It was replaced with the modern automobile factory that still exists today. Large concrete slabs that were previously vital parts of the Fairfax Airport now serve as automobile parking lots. (Both, courtesy of General Motors Heritage Center.)

Discover Thousands of Local History Books
Featuring Millions of Vintage Images

Arcadia Publishing, the leading local history publisher in the United States, is committed to making history accessible and meaningful through publishing books that celebrate and preserve the heritage of America's people and places.

Find more books like this at
www.arcadiapublishing.com

Search for your hometown history, your old stomping grounds, and even your favorite sports team.